IMAGES
of America

THE GREAT DAYTON
FLOOD OF 1913

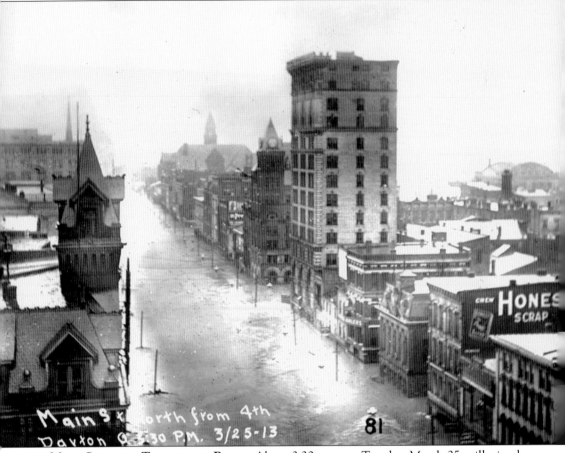

MAIN STREET A TORRENTIAL RIVER. About 3:30 p.m. on Tuesday, March 25, still nine hours before the peak of the flood, water stretches as far as the eye can see looking north along Dayton's Main Street from Fourth Street. The water's strong current, flowing south, is clearly evident. The sky appears almost foggy with heavy rain or low clouds. (Courtesy of the Dayton Metro Library.)

On the cover: **FLOOD RESCUE.** After waters had somewhat receded at Burns Avenue and Catherine Street south of downtown Dayton, people were rescued by one of the flat-bottomed boats manufactured during the 1913 flood by the National Cash Register Company. The dark staining on the lower half of all the brick buildings shows how high the floodwaters had been at their crest. Snow on the roofs also indicates the below-freezing temperatures, adding cold to the flood victims' misery of being wet, hungry, exhausted, and (ironically) dehydrated. (Courtesy of the Dayton Metro Library.)

IMAGES
of America

THE GREAT DAYTON FLOOD OF 1913

Trudy E. Bell

ARCADIA
PUBLISHING

Copyright © 2008 by Trudy E. Bell
ISBN 978-0-7385-5179-1

Published by Arcadia Publishing
Charleston, South Carolina

Printed in the United States of America

Library of Congress Catalog Card Number: 2007937340

For all general information contact Arcadia Publishing at:
Telephone 843-853-2070
Fax 843-853-0044
E-mail sales@arcadiapublishing.com
For customer service and orders:
Toll-Free 1-888-313-2665

Visit us on the Internet at www.arcadiapublishing.com

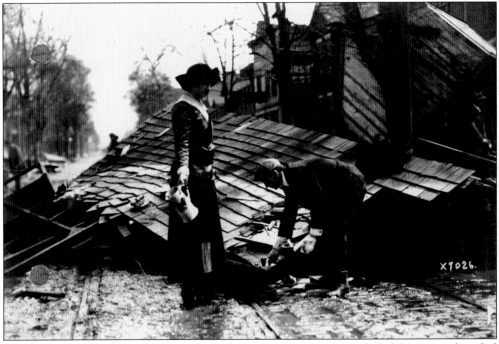

COMING HOME. After total calamity, how does one begin to resume daily life? An unidentified young man and woman on an unidentified street illustrate what thousands of Dayton citizens returned home to after the 1913 flood had devastated much of their city. With precious few possessions rescued, they stand in mud, surveying the wreckage of their home and literally picking up the pieces. But at least they, themselves, had survived. (Courtesy of the Dayton Metro Library.)

Contents

Acknowledgments		6
Introduction		7
1.	High Water	11
2.	Rescue	35
3.	Devastation	51
4.	Relief	73
5.	Recovery and Renewal	87
6.	Resolve	103
Bibliography		127

Acknowledgments

Every book is the creation of many hands; this one is no exception. First, chronologically speaking, thanks to the creators of the Ohio and Erie Canal Towpath bicycle route and its historical markers, which in 2003 first alerted me (not a native Ohioan) to the existence of the 1913 flood. Thanks to Thea Becker in Lakewood, Ohio, for putting me in touch with Arcadia Publishing, and to my tireless Arcadia editor, Melissa Basilone, for the opportunity and her enthusiasm. Thanks also to Travis Sing for his Arcadia book *Omaha's Easter Tornado of 1913* (one of a family of tornados that originated in the same massive storm system that brought the Dayton flood), whose storytelling captions inspired me for my book's approach.

Heartfelt thanks go to the three archives that were so generous with their photographs and time: the Dayton Metro Library (especially to Elli Bombakidis, Nancy Horlacher, and James McQuinn); the Miami Conservancy District (especially to Cindy Manz); and the National Cash Register Archive at Dayton History (especially to Curt Dalton). Additional gratitude to Curt and the Miami Conservancy District's chief engineer Kurt Rinehart for reviewing and commenting on the manuscript; any deficiencies remaining are my own, and I would greatly welcome corrections or additional leads from readers (please feel free to contact me at t.e.bell@ieee.org).

Amazement and thanks are expressed to the hardy newspaper journalists and others in 1913 who had the presence of mind to photograph the trials and anguish surrounding them, documenting the courage of their fellow Dayton citizens.

Warm thanks are also due to fellow historian Craig B. Waff (Wright-Patterson Air Force Base) for his steadfast interest, insights, and encouragement in my 1913 research since its beginning in 2003, and for providing accommodations while I consulted photographs and other sources in Dayton. Thanks and hugs are also due to my wonderful teenage daughter Roxana (and her clueless quadruped, Garrison) for cheerful patience on all too many low-budget 1913 research trips around the nation in an old station wagon.

The book is dedicated to flood victims everywhere.

INTRODUCTION

Truth to be told, the 1913 flood in Dayton was a disaster waiting to happen. The city of Dayton is best visualized as lying at the narrow neck of a funnel, the wide part of the funnel being the Miami Valley to the north and east. The Miami Valley, occupying some 4,000 square miles, is the Great Miami watershed, accounting for a good 10 percent of the entire state of Ohio—more than 2,500 square miles of it above Dayton. Three significant rivers drain the vast watershed and all join their waters just north of downtown Dayton.

The principal river is the Great Miami, which flows through Dayton in a sweeping S, and ultimately empties into the Ohio River near the Indiana border. The Stillwater River, so named because normally it is a placid stream, joins the Great Miami from the northwest in the city's northern outskirts. The Mad River, so named for its turbulence, flows from the northeast and joins the Great Miami as it enters downtown. In the middle of downtown Dayton the Great Miami is joined by Wolf Creek flowing from the west. As if that were not enough, wandering through downtown Dayton was the Miami and Erie Canal, heading south roughly parallel to Main Street. By 1913, the canal was largely out of commission and had become the focus of intense controversy in future city planning because of how the ugly, smelly pollution of its stagnant water was lowering property values, and of the risk of its jamming with debris might aggravate flooding.

Thus, a good half of Dayton—including the heart of downtown—is built on the floodplains of four significant waterways. As such, since the city's founding in 1796 (seven years before Ohio was admitted to the Union in 1803), Dayton had been no stranger to floods. In the 19th century, levees were constructed along the rivers through town; after each flood, the levees were rebuilt ever higher, until by 1913 the levees towered more than 20 feet high. At low water when seasons were dry, that looked like overkill, these massive earthen walls piled sternly above what looked like a piddling little stream making its way south through the mud. But appearances could be deceiving. Floods came, each seemingly stronger than the last. By the early 20th century, people had begun wondering whether all the chopping down of Ohio's virgin forests to make way for farmland might be increasing the runoff of rainwater into the rivers.

But Dayton is not all flat. Away from the rivers' floodplains, hills rise—not big ones, but high enough to afford refuge for those fleeing the rising waters of the 1913 flood. The higher regions of the city include Dayton View to the northwest (west of the Great Miami and north of Wolf Creek), part of Edgemont to the southwest (south of Wolf Creek and west of the Great Miami), and South Park and Rubicon along with the Woodland Cemetery (east of the Great Miami and south of the Mad). On the higher slopes to the south of the city lay both the fairgrounds and

the manufacturing plant of the National Cash Register Company, known locally as either NCR or "the Cash."

Geography is only part of the history of the 1913 flood. Equally important is meteorology.

Although still remembered locally as the great Dayton flood, Dayton's tragedy was actually part of the worst weather disaster ever to befall the entire state of Ohio, with lowland regions statewide underwater from Defiance to Marietta, from Cleveland to Columbus down to Portsmouth and Cincinnati. Actually, flooding extended across the Midwest from Pittsburgh and Parkersburg to St. Louis, and record flood crests pouring into the Mississippi River burst levees as far south as Tennessee and Arkansas. The Easter 1913 storm system that brought the flooding also developed a major family of tornadoes that devastated parts of Nebraska, Iowa, Missouri, and Kansas, including Omaha's Easter tornado of 1913. The 1913 storm system and flood was, in fact, the most widespread natural disaster ever experienced by the United States (at least up to then), far wider in geographical extent than the Great Chicago Fire of 1871, the Johnstown flood in 1889, and the great earthquake and fire in San Francisco in 1906.

A lot of tripe has been written about how three storms converged over Dayton. That statement is simplistic and simply not true. As nearly as can be reconstructed from actual 1913 observations and measurements in such primary sources as the U.S. Weather Bureau's *Monthly Weather Review*, combined with modern-day science, the real story is much more interesting.

Major floods rarely happen out of the blue. The winter of 1913 was unusually warm and wet, and flooding was widespread around Ohio near the end of January. After such a winter, the clayey soil was nearly saturated, unable to absorb any more rainwater. Although February had more normal winter temperatures and snows, the beginning of March was positively sultry. In fact, in the week before Easter, temperatures around Ohio topped a humid 70 degrees Fahrenheit, making the air feel like June.

Then the weather delivered the Midwest—and Dayton—a colossal one-two punch. The first punch came on Maundy Thursday and Good Friday. An arctic high-pressure system swooped down from Canada across the Midwest. Temperatures plummeted nearly 40 degrees in just six hours. Record winds topped 70 miles per hour around all of Ohio and Indiana and gusted above 90 miles per hour in Toledo and elsewhere. The hurricane-force winds rolled carriages off roads and blew down signs, chimneys, and fences. Most importantly, the winds downed hundreds of telephone and telegraph poles around the Midwest. Many not splintered in the windstorm were pulled down by a major ice storm following, which encased wires in tons of ice. Thus, by Holy Saturday—a clear, calm night graced by a total eclipse of the moon—an estimated 8,000 poles and associated wires were on the ground. Across the Midwest, communications were seriously crippled.

The downed poles and wires had two critical consequences. First, the U.S. Weather Bureau was unable to gather complete data about weather systems shaping up around the country. Second, in that era before commercial radio, downed wires resulted in little means for communicating timely weather warnings. Thus the stage was completely set for the weather's second colossal punch: the record rains that began falling on Easter Sunday, March 23.

The U.S. Weather Bureau was completely caught off guard by just how much water fell out of the sky between Easter Sunday, March 23, and Thursday, March 27. Over the Miami Valley and elsewhere across Ohio, the total rainfall those five days ranged from 7 inches to upward of 11 inches—close to three months of normal rainfall. In fact, most places, about half that total fell with tropical intensity (but icy temperatures) on the fateful single day of Tuesday, March 25.

Not only did the rain fall on Dayton. More significantly, it fell on the whole of the Great Miami watershed. Contemporary estimates of the total tonnage and force of the accumulated floodwaters boggle the imagination, putting the volume in the Miami Valley at something like a month's flow over Niagara Falls. Worst of all, the entire tonnage and volume of water gathered over more than 4,000 square miles was funneled right into the heart of Dayton.

With the roaring waters exceeding the normal average flow of the mighty Mississippi River, the rivers rose alarmingly fast. On the morning after Easter, Monday, March 24, the Great Miami was still at about normal height, perhaps six or eight feet deep. Twenty-four hours later, the river

was more than 15 feet deep, nearing the top of the levees. At that point several levees on both sides of the Great Miami burst like breaking dams, and water rushed into several sections of the city with currents so powerful they undermined building foundations. Still the river continued to rise, at times as fast as a foot an hour. In fact, by Tuesday night the Great Miami crested at 29.3 feet deep, 6.5 feet higher than any previous flood. The water rose so fast on Tuesday that people did not have time to pack food or move precious possessions upstairs, or even to escape their office buildings or homes.

Thousands were heroes in Dayton that flood week. Despite rising waters, "telephone girls" and technicians stayed by their posts to keep at one point just a single line working out of Dayton to the rest of the world. Despite the threat to their own lives, many now-unknown folks with rowboats and canoes and ropes braved the flood's ferocious currents to rescue others, some of whom were complete strangers. Not every story can be told.

But one must. That is the story of John H. Patterson (1844–1922), president of NCR, and one of the most ruthless businessmen in the country. Just a month before the flood, Patterson and several dozen of his NCR executives (among them Edward A. Deeds and Thomas J. Watson) had been criminally convicted under the Sherman Antitrust Act for unsavory business practices and sentenced to between three months and a year in jail. They had just appealed their case.

By March 1913, NCR was literally a small city on a hill, employing 7,100 people. A pioneer in "scientific" management, Patterson recognized that employees worked more efficiently if they were physically healthy and mentally fit. So in addition to the cash register manufacturing plant, the NCR grounds had vegetable gardens, a schoolroom, dormitory buildings, tennis courts, and a large kitchen. The simple reason he gave for such pioneering humanitarian treatment of his workers? Two words: "It pays." Thus, NCR was not only well positioned but also well equipped to provide aid in the event of a flood.

It was no accident that NCR stood atop high ground. Raised in Dayton, one of Patterson's first jobs after graduating from Dartmouth College in 1867 was being a toll collector for the Miami and Erie Canal; there he learned not only to weigh freight for calculating tolls, but also received a first-hand view of flooding. Thus, after purchasing the small cash register business in 1884 that he subsequently grew to a major national enterprise, Patterson constructed NCR's world headquarters on high land near his birthplace on Rubicon Farm. NCR—located west of Main Street south of the railroad crossing—had the largest frontage on the Miami and Erie Canal of any business in Dayton, including a wharf for launching and receiving supplies. But the canal, which tended to fill with silt, was expensive to maintain, and the various railroads through Dayton were eroding its business. By 1906, Patterson was convinced the canal was more of a liability to Dayton than an asset.

Also by then Patterson was concerned whether NCR was positioned high enough to survive a major flood—so concerned, in fact, that in 1906 he commissioned Chicago-based hydraulic and sanitary engineers John W. Alvord and Charles B. Burdick to evaluate its location. Alvord's report indicated that future Dayton floods might be larger than past floods because of two factors: the denuding of hills of trees with their water-retarding roots to turn forests into farmland, and the increased building of levees that constricted the width of rivers at the cost of raising their heights. This report, plus other unrelated issues, eventually led Patterson to issue a public threat to move out of Dayton to some other city.

Then came the great Dayton flood. Through NCR, Patterson saved literally thousands of lives. His leadership was given legal force from Ohio governor James M. Cox. On March 28, Cox directed Adj. Gen. George H. Wood, military governor of Dayton for the six weeks the city was under martial law, to appoint a Dayton Citizens' Relief Committee composed of the mayor and leading Dayton industrialists. Wood appointed Patterson the committee's head. Through the relief committee, Patterson oversaw the city's immediate relief and rehabilitation. In short, he became a national hero. Patterson so redeemed himself in the eyes of the public that newspaper editorials around the nation urged Pres. Woodrow Wilson to pardon the antitrust conviction. Ultimately, Patterson effectively won his case on appeal.

Dayton became the human face of the entire 1913 flood, much as in 2005 New Orleans became the human face representing the wider geographical suffering across Louisiana and Mississippi wrought by Hurricane Katrina. Of the official count of 462 flood deaths across Ohio, 98 souls perished in Dayton, the greatest number in any one city.

But Dayton's tragic story has a truly happy ending. In April 1913, the Ohio state legislature passed an emergency act authorizing the mayor of any city to appoint an emergency commission to expedite long-term repair and reconstruction. Dayton officially incorporated its three-week-old relief committee into the not-for-profit Dayton Citizens' Relief Commission—again with Patterson as its head. By early May, convinced that the Federal government was unlikely to act to prevent a recurrence of a future disastrous flood in the Miami Valley (in part because the valley is almost completely within the borders of the single state of Ohio), the commission established a flood-prevention fund—again with major seed money from Patterson and NCR to inspire other donors. After a monumental fund-raising campaign of only 10 days, the fund received pledges for more than $2 million—enough to begin financing engineering surveys, plans, and construction contracts for a fix-it-forever flood-control program.

The result was the creation of the Miami Conservancy District to build a system of five massive earthen dams and dry detention basins across the Great Miami, Mad, and Stillwater Rivers as well as across Twin and Loramie Creeks—the single largest-scale engineering project ever undertaken in the United States until then. The district's goal was to protect not only Dayton, but all other cities within the Miami Valley both above and below Dayton, which had also suffered extensive tragic losses in 1913 (among them Troy, Piqua, Hamilton, and Middletown).

In 1918, after delays for World War I, the Miami Conservancy District sold two issues of bonds and began moving earth. The five earthen dams were mammoth. Their chief engineer Arthur E. Morgan compared their construction to that of the 40-story-high great pyramid in Egypt. In fact, by the time construction was completed in 1923, the men of the Miami Conservancy District had rearranged a volume of earth almost equal to five great pyramids. They also incorporated several truly clever technical innovations that were later adopted by the Tennessee Valley Authority and other flood-control projects.

Most importantly, the earthen dams have withstood the test of time, holding back floodwaters more than 1,500 times. Even in 1937 and 1982 (when rain and flood stages approached the magnitude of 1913) and in 1959 (year of highest watershed runoff in the Miami Valley since 1913), downtown Dayton has remained safe, sound, and dry.

One last detail: money figures are given in their 1913 dollars. Although difficulties always attend trying to figure out "what that means in real money," the equivalent buying power today is at least 20 times greater: in other words, $25 in 1913 dollars would be roughly equivalent to at least $500 today.

One
HIGH WATER

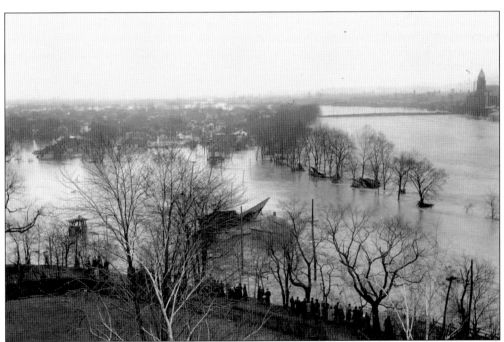

SWOLLEN MIAMI RIVER. Around 7:00 a.m. on that fateful Tuesday morning, March 25, 1913, the levees first broke on the north side of the Great Miami River, flooding Riverdale and North Dayton. This photograph looks across half-submerged Riverdale toward downtown across the river. Judging from the edges of the flood later plotted on a map of Dayton (see page 17), the line of people may be standing along Forest Avenue. One of the towers of Steele High School on Main Street is visible in the distance at the far right. The Main Street Bridge linking downtown Dayton with Riverdale is seen as a distant horizontal line lying virtually atop the swollen river. (Courtesy of the Dayton Metro Library.)

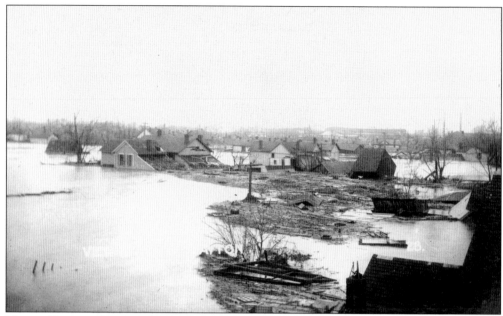

NORTH DAYTON STRUCK. Exact chronology is difficult to reconstruct, but North Dayton and Riverdale seem to have been flooded first, possibly half an hour before the levees gave way across the river along Monument Avenue. Eventually North Dayton was submerged up to the second story. Many Hungarian, German, and other European immigrant factory workers lived in North Dayton, and the most lives were lost here. (Courtesy of the Dayton Metro Library.)

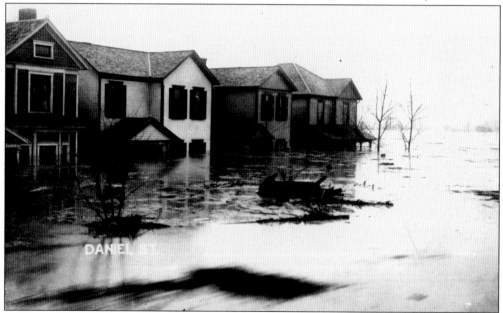

RIVER LIKE A LAKE. On Daniel Street in Riverdale, houses were submerged almost to the top of the first story. The merged waters of the Great Miami and the Stillwater, along with those of a swollen local creek, stretch almost like a turbulent lake. The heads and shoulders of two people can be distinguished in the second floor window of the dark house at the far left. (Courtesy of the Dayton Metro Library.)

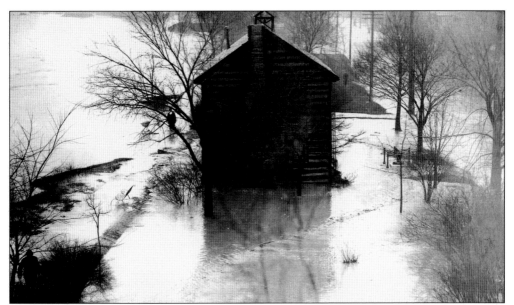

FLOOD BREACHES THE LEVEE. Meanwhile, the Great Miami first overtopped the levee on its southern bank along Monument Avenue close to the Main Street Bridge. Floodwaters began surging into downtown Dayton. Near the breach, water surrounded the Newcom Tavern, the oldest surviving structure built in Dayton, which sat behind Steele High School in Van Cleve Park between the levee and Monument Avenue. Miraculously, the log tavern—more than a century old—survived. (Courtesy of the Dayton Metro Library.)

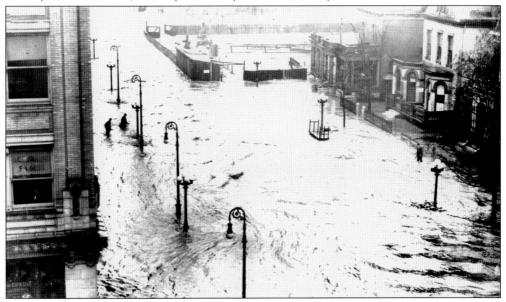

FIERCE CURRENT DOWN FOURTH STREET. By midmorning on Tuesday, looking east along Fourth Street from Ludlow Street, the floodwater was between knee and hip deep (two men at left, one at right). The bases of the five-globed streetlamps are still visible; the lamps, 13 feet high, make an excellent depth gauge in photographs of flooded Dayton. Construction in the background was excavation for the Elder and Johnston Building. (Courtesy of the Dayton Metro Library.)

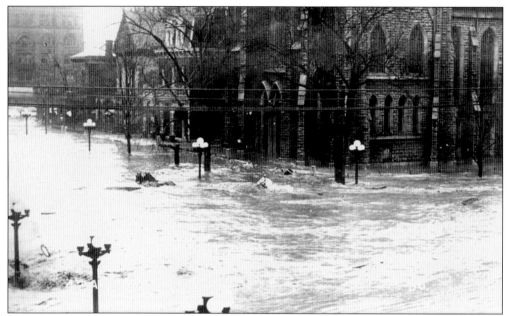

FLOOD RISES HIGHER. Sudden torrents of water rushed through the main business district at up to 25 miles per hour. Three horses struggle against the stiff current. The pair of photographs on this page was likely taken from the building of the Dayton Daily News at Ludlow and Fourth Streets. Note the fierce whirlpools around the half-submerged five-globe streetlamps. The dark building to the far right is the First United Brethren Church. (Courtesy of the Dayton Metro Library.)

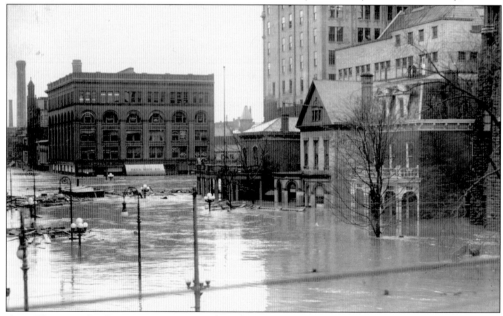

AND HIGHER. At the same corner Tuesday afternoon, the floodwater was near the necks of the five-globed streetlamps, making it deeper than 10 feet. On the distant multistory building, a light-colored awning (which reads "Reed Shoe Company") is just above the water. What looks like a large box left of the awning is actually the lifted roof of the construction shed in the excavation for the Elder and Johnston Building. (Courtesy of the Dayton Metro Library.)

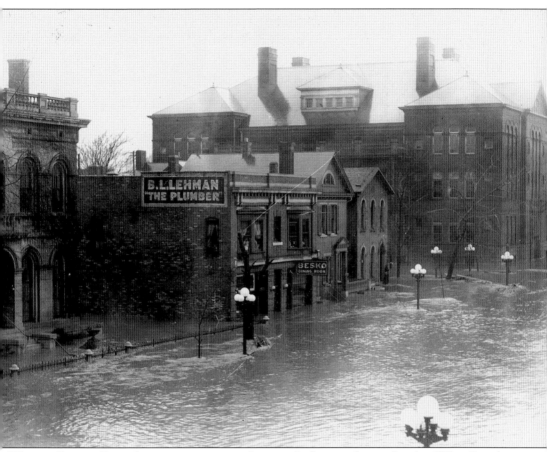

WATERS RISING. From the same intersection, but now looking at the south side of West Fourth Street between Ludlow and Wilkinson Streets, the rising floodwaters are shown from a different angle. In this picture, taken earlier in the flooding, the five-globed streetlamps are not yet half-submerged. (Courtesy of the Dayton Metro Library.)

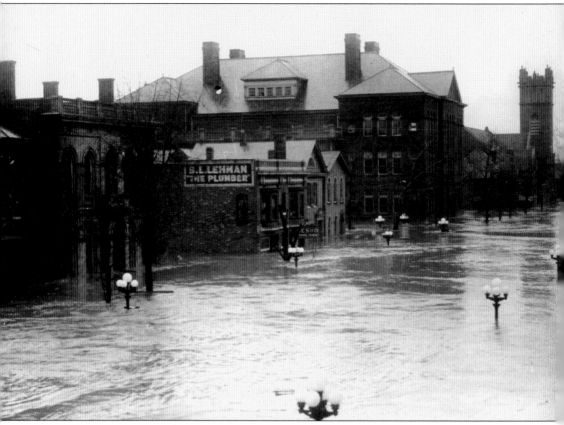

HIGHER WATER. Several hours later, the swiftly flowing floodwaters were nearly up to the necks of the five-globe streetlamps and to the ceilings of first floors of shops along West Fourth Street as seen from Ludlow Street. Maximum flood height, reached between midnight and 2:00 a.m. on Wednesday, appears not to have been documented in photographs. The large building with the two chimneys is the Central District School; at the far right is the First United Brethren Church. (Courtesy of the Miami Conservancy District.)

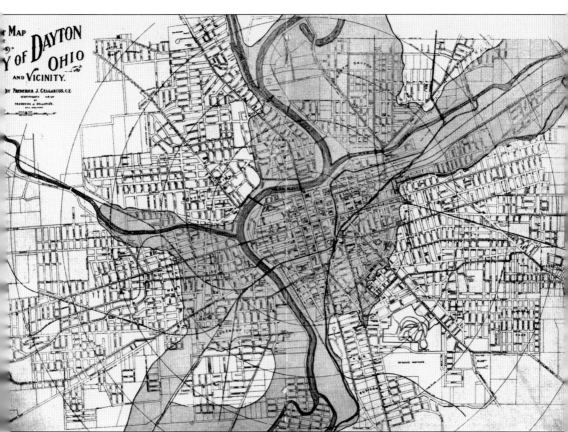

MAP OF FLOODED AREAS. An area more than seven square miles of Dayton was underwater in the 1913 flood, including the entire business district. Plotted on a 1910 base map, all the areas in gray were flooded; the concentric circles indicate miles from center of downtown at the intersection of Third and Main Streets. Near the bottom of the map southwest of downtown, note that part of Edgemont was literally an island. The outlines of the flooded areas shown correspond generally, but not exactly, to a similar flood map plotted by the Ohio State Board of Health. The curving river flowing from the north (top) is the Great Miami, augmented by the normally placid Stillwater River coming in from the northwest (upper left). The rushing Mad River flows from the northeast (upper right) and joins the Great Miami within downtown Dayton. Wolf Creek from the west (left) also joins the Great Miami within Dayton. Half of Dayton was—and still is—built on floodplain. (Courtesy of the Dayton Metro Library.)

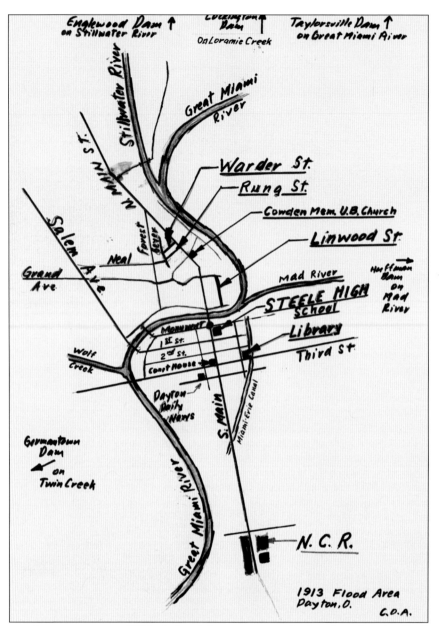

PRINCIPAL LANDMARKS IN 1913. A hand-drawn map made decades after the flood points out the key streets and the positions of principal landmarks in 1913, including the position of the National Cash Register Company (NCR) where Main Street rises south of downtown. Immediately to the north of NCR was the Miami Valley Hospital and immediately to the west were the fairgrounds, both also on higher ground. The Miami and Erie Canal ran right past the Dayton Public Library; after the 1913 flood, NCR's president John H. Patterson carried the day for decommissioning and filling in the canal. The canal route was later paved and now forms diagonal and wandering Patterson Boulevard; it still runs past the public library, which is now in a more modern building and is called the Dayton Metro Library. The arrows at the top next to the names of three dams point in the direction of mammoth flood-control works built after the 1913 flood that still protect the city of Dayton today. (Courtesy of the Dayton Metro Library.)

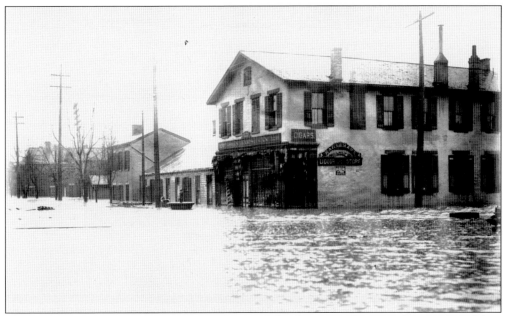

EAST THIRD STREET AT FRONT STREET. East of the downtown business district along Main Street, floodwater was also rising around the John Harshman Family Liquor Store (1219 East Third Street), a white building on the northwest corner of Third and Front Streets. This photograph may have been taken near the beginning of the flood, as the water appears not yet to have reached first-floor windows. (Courtesy of the Dayton Metro Library.)

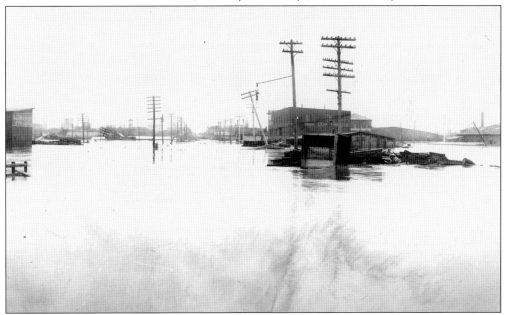

AS FAR AS THE EYE COULD SEE. At higher water, flooded First Street as seen from the corner of Front Street looking west toward Keowee Street looked almost like a vast open sea. Based on the direction of the current later plotted by the Ohio State Board of Health, most of the water visible from this location was likely from the Mad River somewhere off to the right. (Courtesy of the Miami Conservancy District.)

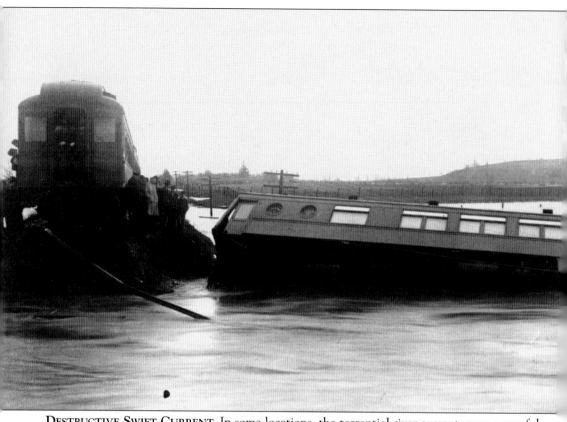

DESTRUCTIVE SWIFT CURRENT. In some locations, the torrential river currents were powerful enough to sweep away massive structures. Here an interurban railroad car has been separated from the rest of the train and swept away along with the rest of the railroad bed. A number of stranded passengers look on helplessly. (Courtesy of the Dayton Metro Library.)

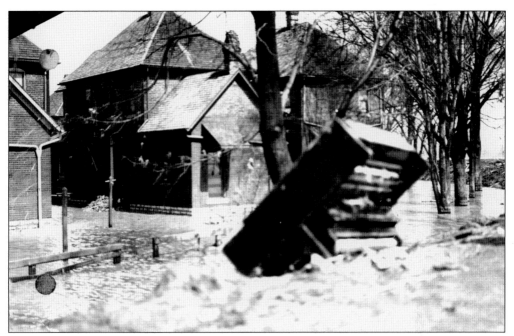

TRAVELING MUSIC. The swift current swept along massive objects at high speed. Judging from the focus of the image, likely the photographer had set up the camera to take a picture of the houses in the background and snapped the shutter just as an upright piano was carried into view so fast there was no chance to refocus the lens. (Courtesy of the Dayton Metro Library.)

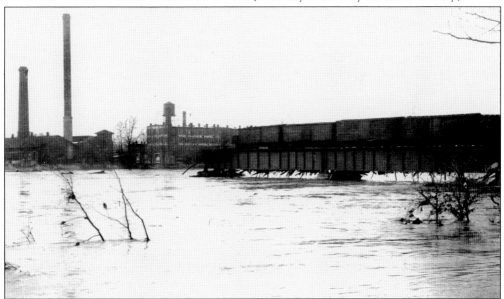

RAILROAD BRIDGE DESTROYED. Even when freight cars laden with coal were holding the Dayton and Union Railroad Bridge at Sixth Street in place, the swollen Great Miami wrested half the bridge from its moorings. That was a blessing in disguise. The bridge was so low that it acted like a dam, spreading the water and threatening the levees on both banks, moving some city leaders on Tuesday morning to seek authority to dynamite it. (Courtesy of the Miami Conservancy District.)

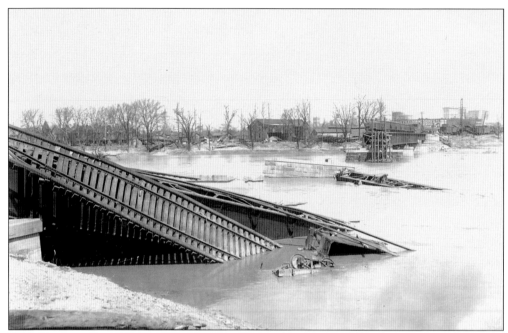

FULL DAMAGE REVEALED. Only after the floodwaters had receded was the full extent of the damage to the Dayton and Union Railroad bridge at Sixth Street revealed. The powerful Great Miami had simply twisted the rails and supporting steel structure off their concrete piers, stranding steel girders in the river. (Courtesy of the Miami Conservancy District.)

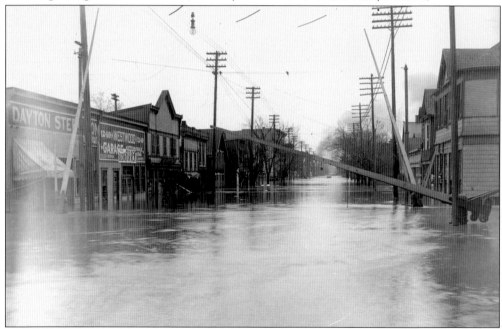

CALMER WATER SOME PLACES. Yet, because of location and local topography, in other parts of Dayton the floodwaters rose quietly. Indeed, some flooded sections were spared the worst destructive force of scouring currents. One such location was East Third Street near the crossing of the Pennsylvania Railroad (about Webster Street). (Courtesy of the Miami Conservancy District.)

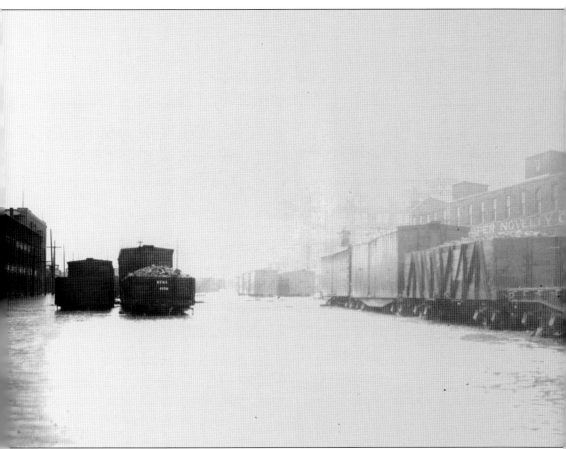

FLOODED TRAIN YARDS. The floodwaters rose so quickly that freight and passenger trains were stalled and workers could not escape the train yards. Here a man atop a boxcar, barely visible through the haze, possibly stranded, watches the flood at Bacon Street between Dutoit and Montgomery Streets. The building in the background is the E. C. Harley Company; on the right is the Dayton Paper Novelty Company. (Courtesy of the Dayton Metro Library.)

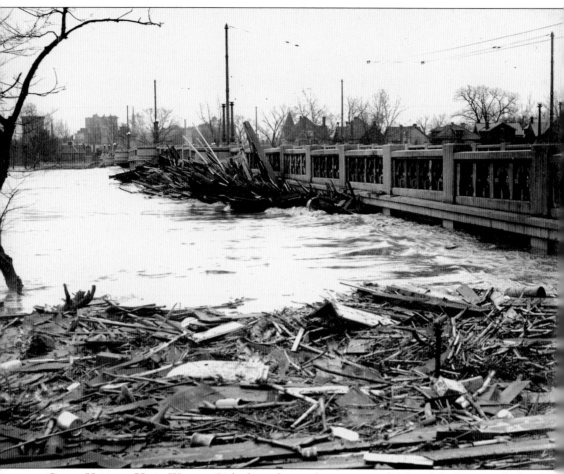

CLOSE VIEW OF HIGH WATER. Onlookers clustered on concrete bridges (which generally fared better than steel bridges) to get a good view of the flood, or to escape the water in lower areas. On Tuesday afternoon, people on the north end of the Dayton View Bridge watched flood debris collecting on the upstream (north) side of the bridge. In the distance, above the houses, stand a few buildings of downtown Dayton. (Courtesy of the Miami Conservancy District.)

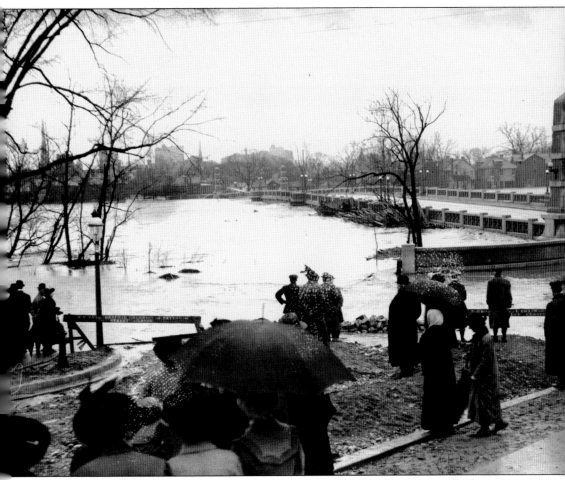

DAYTON VIEW BRIDGE FROM GRAFTON. A bit later on Tuesday, the Great Miami had risen so high that people moved off the Dayton View Bridge to watch high water from a safer distance in the Grafton Hill District. And still, as the umbrellas attest, rain continued to fall apace. (Courtesy of the Miami Conservancy District.)

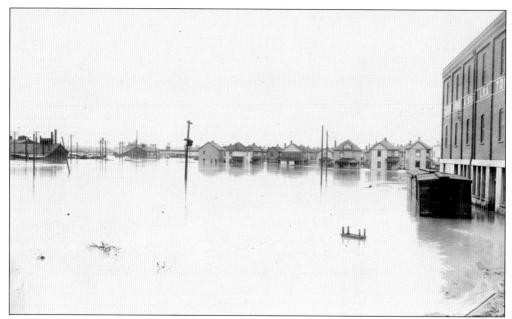

THE HYDRAULIC. Almost unrecognizable during the flood was the industrial area at Webb Street near the hydraulic race. "The hydraulic" was a narrow channel for delivering water from the Mad River at high speed to power various factories, although by 1913 steam power or electricity had largely replaced waterpower. This photograph is the easternmost in this book, but the floodwaters extended another mile farther east. (Courtesy of the Miami Conservancy District.)

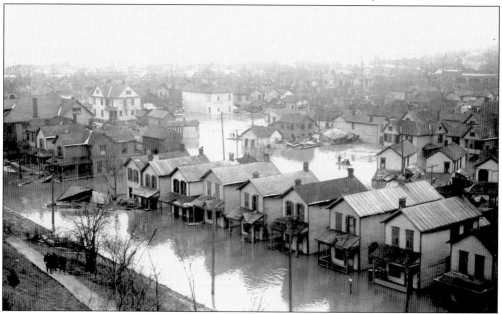

FLOODED NEIGHBORHOODS. Looking northwest from the high ground of the Miami Valley Hospital near NCR and the fairgrounds, the flooding clearly pervades a residential neighborhood in southern Dayton. At the bottom of the photographer's hill is Apple Street. In the middle of the photograph, note a collapsed house and several people on two rectangular flatboats (more about those boats appears in chapter 2). (Courtesy of the Dayton Metro Library.)

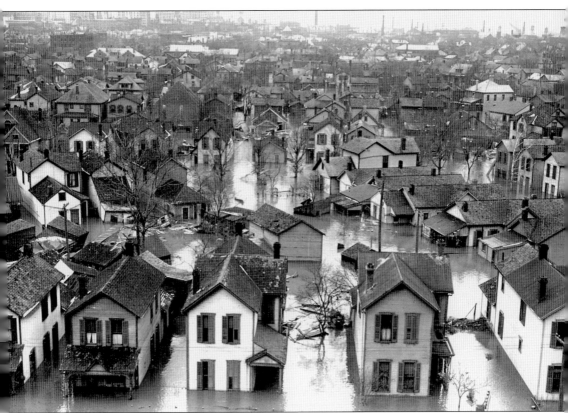

POWER OF FLOODING. Another aerial view from Miami Valley Hospital looking due north over Apple Street toward downtown Dayton begins to reveal some of the destruction to homes in the city's southern sections due to the floodwaters' powerful currents. Several homes have been moved from their foundations and so sit at odd angles with respect to their neighbors, and floating debris is clearly visible between houses. (Courtesy of the Miami Conservancy District.)

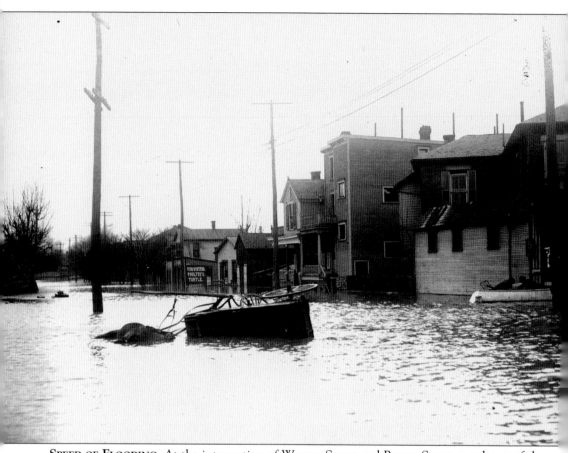

SPEED OF FLOODING. At the intersection of Warren Street and Brown Street, northeast of the Miami Valley Hospital, the streets were completely impassable except by boat (note the two figures to the far right with a canoe). Water here was probably between knee and hip deep, judging from the overturned cart and drowned horse in the center of the photograph. (Courtesy of the Miami Conservancy District.)

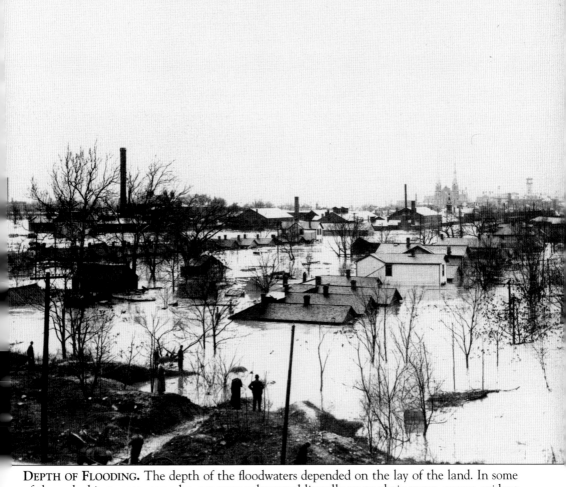

DEPTH OF FLOODING. The depth of the floodwaters depended on the lay of the land. In some of the unluckiest areas, some houses were submerged literally up to their eaves, as was evident to these viewers standing on the higher ground of the fairgrounds and looking northwest over Dayton proper. Catherine Street is in the foreground. (Courtesy of the Dayton Metro Library.)

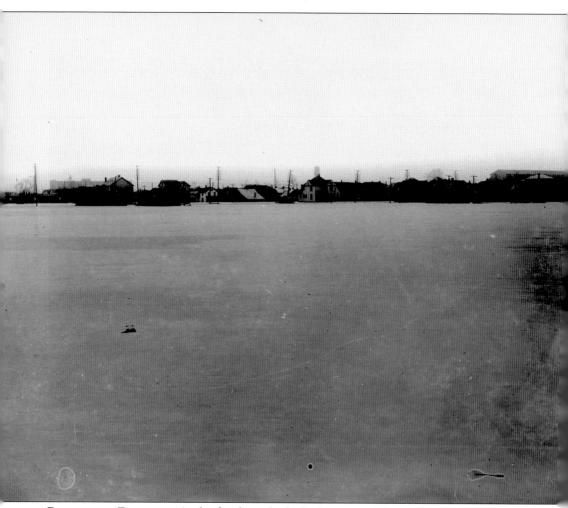

BREADTH OF FLOODING. At the flood's peak, the highest part of the residential neighborhood of Edgemont southwest of downtown Dayton was literally an island, temporarily isolated from the rest of the world. This photograph shows how Edgemont appeared from a point west of Broadway and north of Bohlende Avenue. (Courtesy of the Miami Conservancy District.)

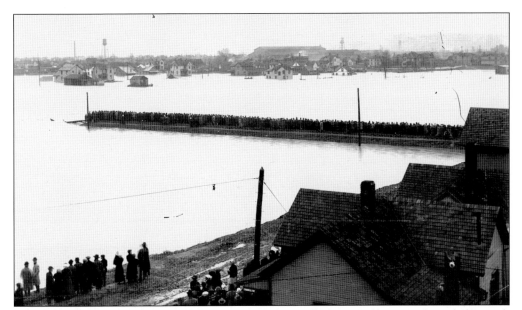

A RIVER FLOWS THROUGH IT. The Great Miami swelled more than a mile wide on each side, overspreading the lowlands to the west of Edgemont. This view, looking southeast across Burbank Park, was taken from South Summit Street below Willard School. What looks like a pier in the middle ground is actually the embankment of the Cincinnati, Hamilton and Dayton railroad, crowded with thousands of onlookers. (Courtesy of the Miami Conservancy District.)

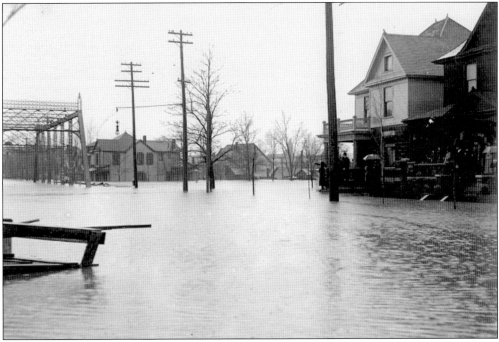

IMPASSABLE BRIDGES. Across the Great Miami two miles west of downtown Dayton, the floor of the Broadway Bridge over Wolf Creek was at least 20 feet above the bottom of the creek's channel. Yet at the height of the flood, the bridge itself was hip-deep. Note the watching people clustered on the porches of the two homes to the right. (Courtesy of the Miami Conservancy District.)

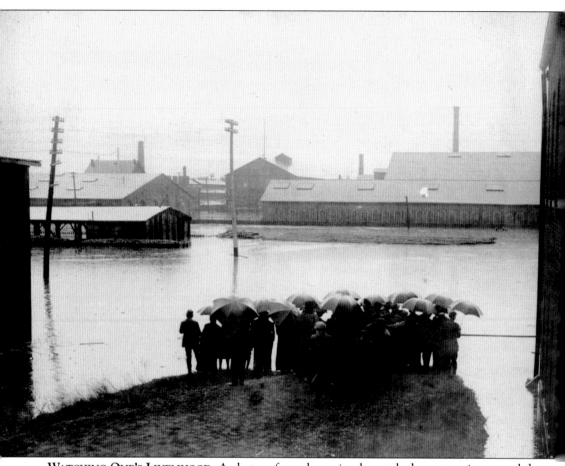

WATCHING ONE'S LIVELIHOOD. A cluster of people anxiously watch the waters rise around the East Shops of the Barney and Smith Car Company. Preceding the Pullman Company, Barney and Smith was a major national manufacturer of freight and passenger railway cars and one of Dayton's largest industries and employers. (Courtesy of the Miami Conservancy District.)

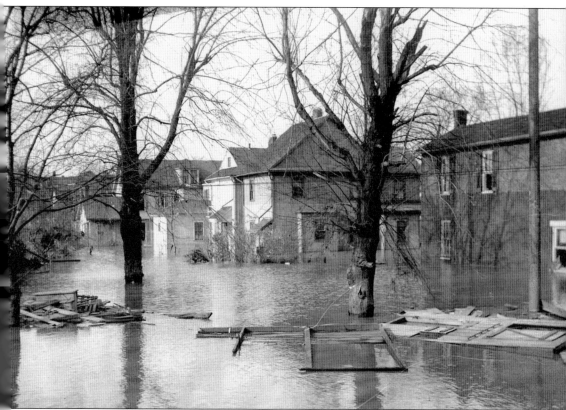

DRIVEN INTO THE ATTIC. In Riverdale and other sections of Dayton, the floodwater reached above the floor of the second story, driving people into their attics. Although the water had receded by the time this photograph was made, the darker high-water marks on the building to the right clearly attest to the fact that it had recently reached a good 10 feet higher. (Courtesy of the Miami Conservancy District.)

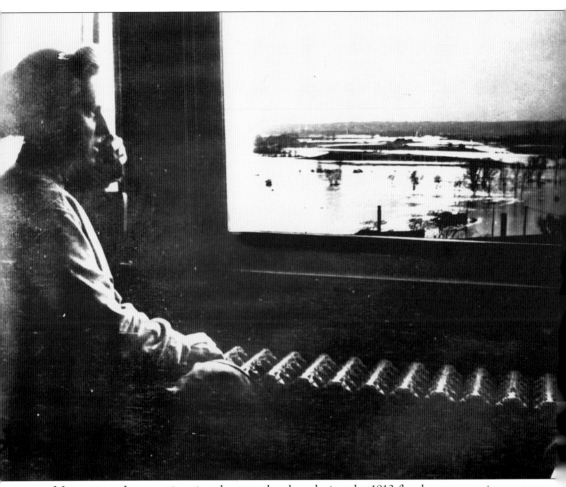

MAROONED. In a rare interior photograph taken during the 1913 flood, a woman sits next to a radiator watching the floodwaters from her second-floor window. There was little the marooned could do but wait for the water to subside, and pray for rescue. (Courtesy of the Dayton Metro Library.)

Two
Rescue

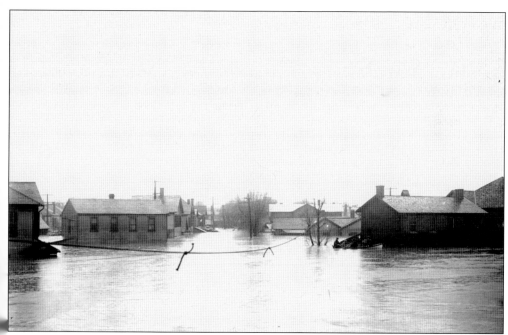

Lifelines. Where current was strong and distance was large, several ropes were knotted together to reach all the way across the floodwaters for a rescue, as was necessary here on Burns Avenue in the south of Dayton. With five people aboard, the boat (in front of house to right) is riding perilously low. (Courtesy of the Dayton Metro Library.)

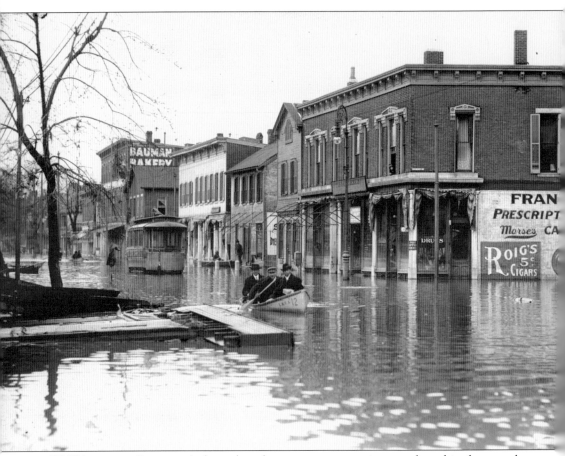

YMCA TO THE RESCUE. At least three boat rescues were going on when this photograph was taken. This view is west from Crescent Street looking toward the north side of West Third Street. The boat in the foreground, designated "Y.M.C.A. 12" is being propelled by a man in working clothes who apparently has rescued two men in dress clothes. The other two boat rescues are just behind the YMCA canoe to the right of the stranded streetcar, and to the far left of the picture. Identifiable buildings include the Frank Schwik Drug Store (at right) and the Bauman Bakery (in the background). (Courtesy of the Dayton Metro Library.)

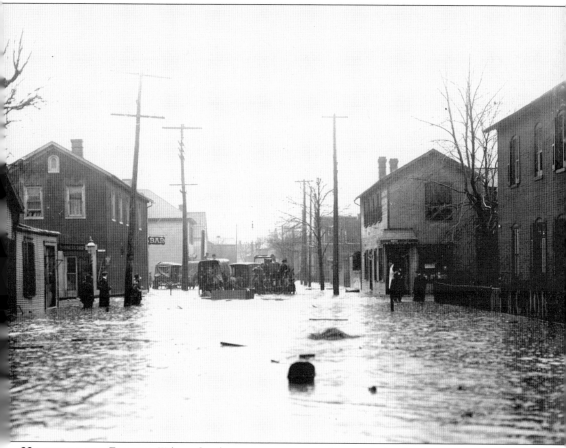

HORSES TO THE RESCUE. Where floodwaters were not too deep at their edges, or as soon as they had receded enough to let through teams of horses, carriages and carts appeared in the flooded streets to rescue people and begin the labor of cleanup. The water in this unidentified location appears to be above ankle height. (Courtesy of the Miami Conservancy District.)

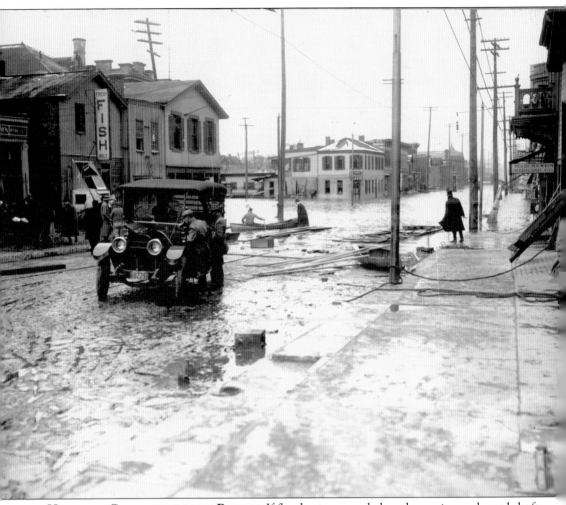

HORSELESS CARRIAGES TO THE RESCUE. If floodwaters were below the engine and crankshaft, even some automobiles were pressed into service on the muddy streets. In this photograph looking north on Wayne Avenue at the intersection of Burns Avenue, note the high-water marks on the buildings between the first and second stories. (Courtesy of the Dayton Metro Library.)

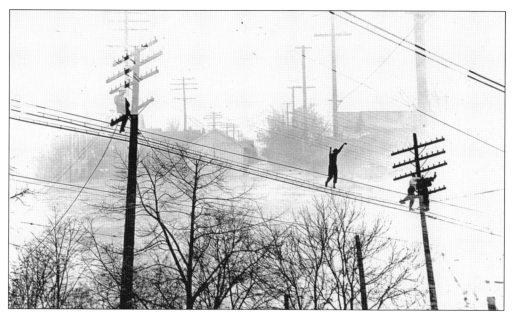

AERIAL RESCUES. Late Tuesday afternoon, near the intersection of Main and Foraker Streets, an explosion (possibly from a gas main) collapsed several buildings. Desperate survivors from those buildings escaped only by grasping hold of telegraph poles and making their way to the heavy cable above. Then they literally walked a high wire above turbulent waters. (The original negative for this photograph was accidentally double-exposed with another flood scene.) (Courtesy of the Miami Conservancy District.)

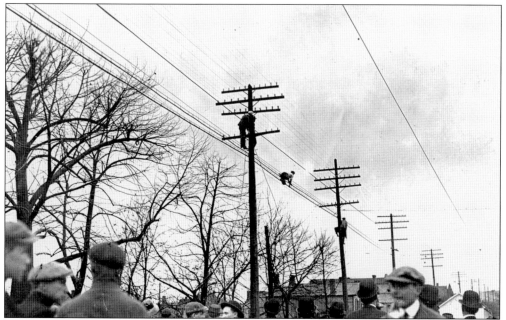

DOWN TO SAFETY. One figure, possibly a woman, apparently felt safer crawling along the telegraph wires until all the daring flood escapees were close enough to reach willing hands that carried them to safety. Thronging below the telegraph wires were other flood victims crowded together on the higher land at the fairgrounds. (Courtesy of the Miami Conservancy District.)

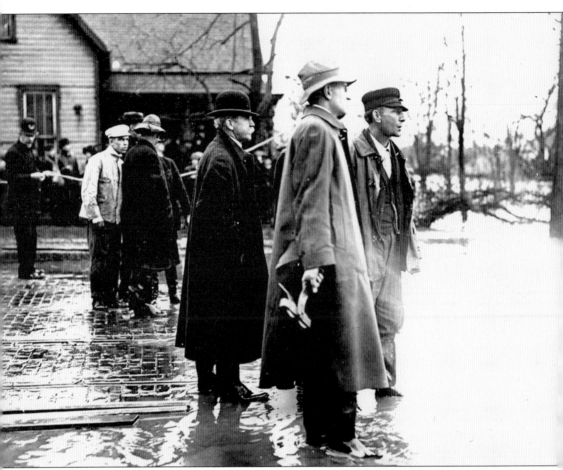

THE MAN WHO RESCUED THOUSANDS. Slight, vigorous, 69-year-old John H. Patterson, in the dark coat and derby just left of center, was the president of the NCR, known locally as "the Cash," and one of Dayton's largest industries with 7,100 employees. Long concerned about the possibility of a major flood in Dayton, Patterson knew that NCR's higher ground would be a natural refuge for anyone fleeing rising floodwaters. Before dawn on Tuesday, March 25, after climbing to an NCR roof and seeing the Great Miami nearly at the top of its levees, Patterson made his decision. He declared to his executives that until further notice, NCR was temporarily out of commission and was instead the Dayton Citizens' Relief Association. He assigned woodworking to manufacture flat-bottomed boats big enough for six people plus the rower, the commissary to bake 2,000 loaves of bread and prepare 500 gallons of soup, hydraulics to keep the NCR well pumping 24 hours, and purchasing to buy blankets and other staples; he also directed that large Building No. 10 be converted into sleeping areas, hospital, and headquarters. (Courtesy of the Miami Conservancy District.)

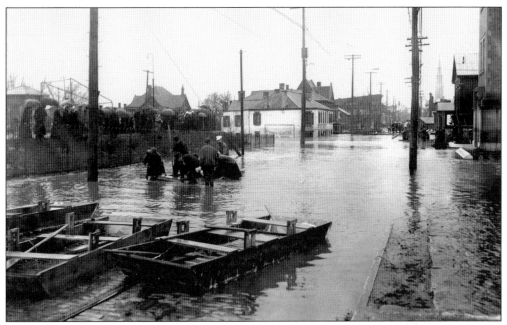

NCR RESCUE BOATS. Possibly the most significant thing Patterson did through NCR was directly save hundreds of lives. NCR carpenters built nearly 300 of the flat-bottomed boats at the rate of four per hour and then sent them forth to rescue the marooned, such as these people near Bomberger Park. The photographer was looking west along East Fifth Street at Eagle Street. (Courtesy of the Dayton Metro Library.)

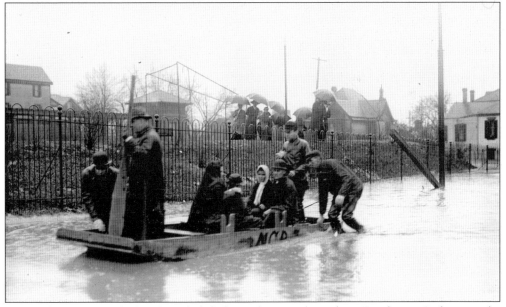

FAMILY RESCUED BY NCR. In a slightly later photograph made at Bomberger Park, it can be seen that the flat-bottomed NCR rescue boats had a very shallow draft (note that water here is very shallow) and were very stable, allowing half a dozen flood victims to be rowed to safety. Note the initials "NCR" painted on the boat's side (below the oarlocks).(Courtesy of the Miami Conservancy District.)

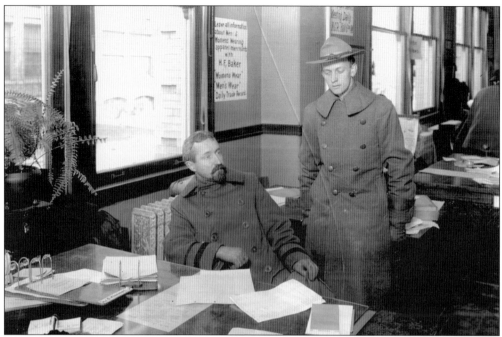

NCR AS MILITARY HEADQUARTERS. NCR Building No. 10 became one base of operations for the Ohio National Guard, headed by Adj. Gen. George H. Wood, seated. With communications downed, civil government was demoralized. On Tuesday, martial law was declared in Dayton with Wood serving as the city's military governor until May 6. Standing next to Wood is his aide-de-camp Lt. Charles Parrott. (Courtesy of the Dayton Metro Library.)

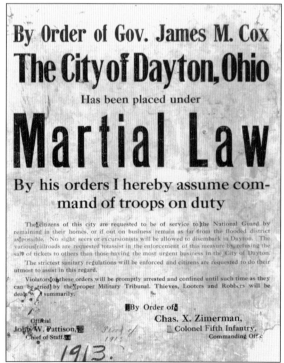

MARTIAL LAW NOTICE. Gov. James M. Cox put much of Ohio, including the county of Montgomery and the city of Dayton, under martial law. General Wood divided Dayton into six military districts, placing John H. Patterson in charge of the South Park district. Col. Charles X. Zimerman (sometimes spelled Zimmerman), mentioned on this notice, was placed in charge of the district of East and Southeast Dayton. Wood himself took charge of Central Dayton, his title becoming brigadier general, commanding the Dayton military district. (Courtesy of the Dayton Metro Library.)

EMERGENCY PASS. Under martial law, any citizen needing to be out after curfew (which extended every night from 6:00 p.m. to 5:30 a.m.) had to secure an emergency pass. Workers at public utilities companies, which were repairing damaged plants and wiring, had passes good for all times, but all others were issued passes good only for a specific night. This emergency pass, good for all times, has been signed by Patterson. (Courtesy of the Dayton Metro Library.)

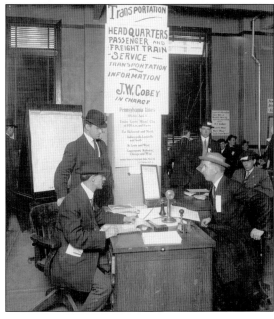

TRANSPORTATION HEADQUARTERS. Rail service through flooded districts was also coordinated at NCR for both passengers and freight. (Courtesy of the Dayton Metro Library.)

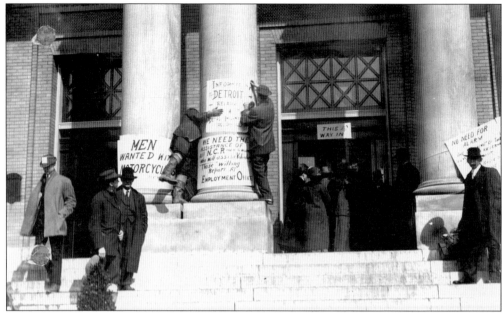

NCR NEWS CENTRAL. On the front steps outside the main NCR building—now the NCR flood relief headquarters—signs were posted calling for volunteers with various needed skills and assets (such as motorcycles) and were also used for calming wild rumors (the sign at the far right titled "No need for alarm" aims to put to rest false reports about the bursting of the Lewiston Reservoir). (Courtesy of the Dayton Metro Library.)

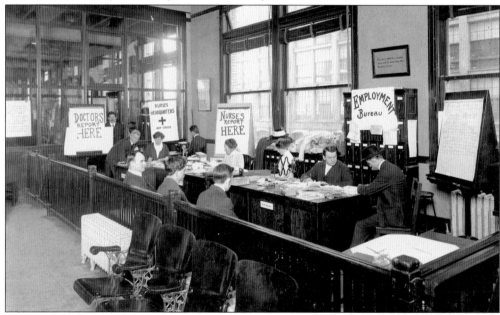

NCR EMPLOYMENT DEPARTMENT. Inside NCR Building No. 10 on the first floor, nurses, doctors, and other professionals with skills useful in the relief effort could report for duty either to NCR or to the Red Cross (at the back of the room). At its peak, the Red Cross operated 48 relief stations around Dayton, many of them in schools and churches, giving emergency aid to 9,000 families totaling some 35,000 individuals. (Courtesy of the Dayton Metro Library.)

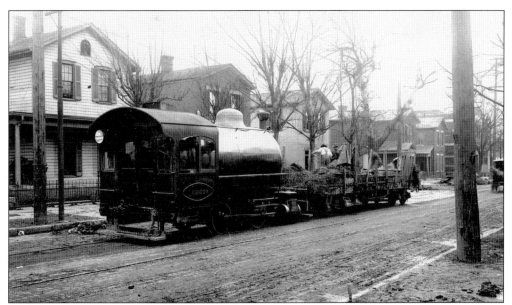

NCR IN CLEANUP. The Rubicon, one of three fireless steam engines owned by NCR, helped to haul away flood debris by pushing a wagon down a street. A fireless steam engine returned to a central location a couple times a day to be recharged with superheated water (400 degrees Fahrenheit, well above boiling) at high pressure (12 times atmospheric pressure), which instantly turned to steam when released through valves, producing pressure for running the engine or brakes. (Courtesy of the Dayton Metro Library.)

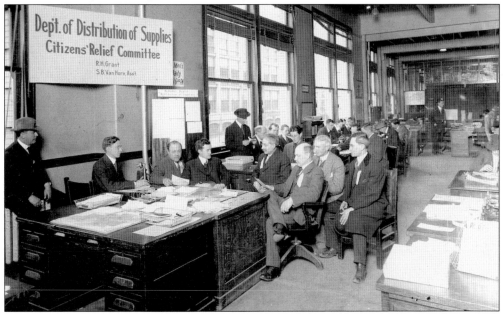

CITIZEN'S RELIEF COMMITTEE. At noon on Friday, March 28, Ohio governor James M. Cox directed Adj. Gen. George H. Wood to appoint a Citizens' Relief Committee for Dayton. The first meeting was held two hours later. Wood appointed John H. Patterson as chairman of the Citizens' Relief Committee, whose headquarters also occupied the north side of NCR Building No. 10. (Courtesy of the Dayton Metro Library.)

NCR as Newspaper Printer. When the newspaper presses of the *Dayton Daily News* were submerged under floodwaters, John H. Patterson allowed the newspaper to continue publishing using NCR's own printing presses. This issue, for Friday, March 28, announced that Patterson was just appointed president of the Citizens' Relief Committee, and that Ohio governor James M. Cox ordered the National Guard to comply with all the committee's demands. Public health bulletins and other vital notices were also printed. (Courtesy of the Dayton Metro Library.)

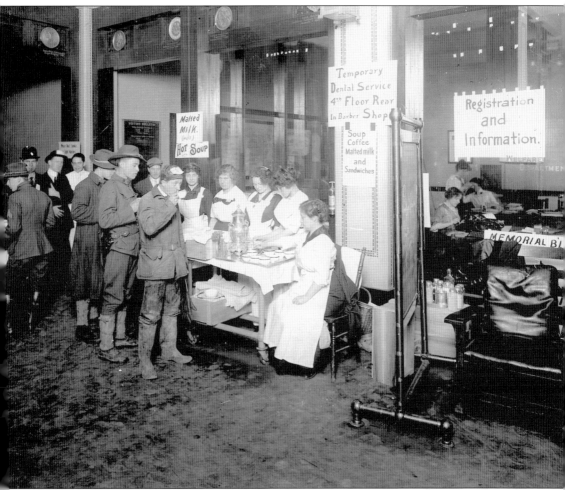

ROUND THE CLOCK SUSTENANCE. Inside the main entrance of NCR on the first floor, kitchen staff provided hot coffee, soup, sandwiches, and other provisions to the military personnel, newspaper reporters, and other relief workers. Note the thick mud on the boots and pants legs of the men in line as well as on the floor. The Citizens' Relief Committee continued to provide daily food for weeks, feeding a maximum of 83,000 people on Tuesday, April 1. (Courtesy of the Dayton Metro Library.)

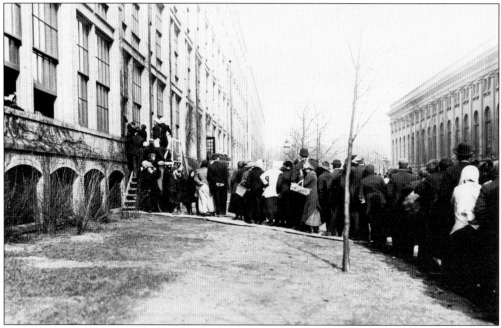

SUPPLIES LINE. In the meantime, NCR also provided sustenance for flood refugees. People lined up at a temporary entrance to NCR Building No. 4 to obtain requisitions for emergency supplies based on their need. Then they took those requisitions to Building No. 10 to receive those supplies at no charge. (Courtesy of the Dayton Metro Library.)

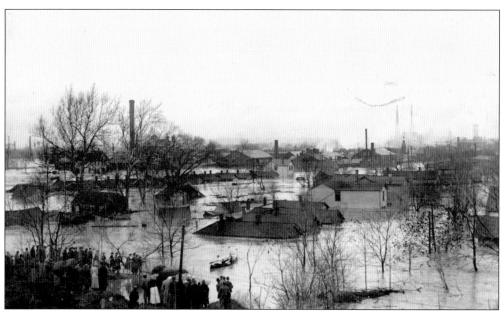

PATTERSON TO THE RESCUE. John H. Patterson not only opened his company to flood refugees; he also personally risked his own life in a canoe (bottom center of photograph) to rescue two women and a small child trapped on a roof. Although slightly built and in his 60s, Patterson was wiry and physically vigorous. (Courtesy of the Dayton Metro Library.)

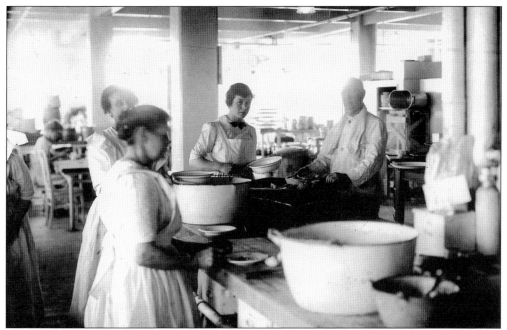

ALL HANDS ON DECK. Not only did Patterson himself literally get his hands and feet muddy in flood relief, Patterson's son Frederick also rescued a number of people, and his daughter Dorothy (young woman in center) helped prepare meals for flood victims in the kitchen on the first floor of NCR Building No. 10. (Courtesy of the Dayton Metro Library.)

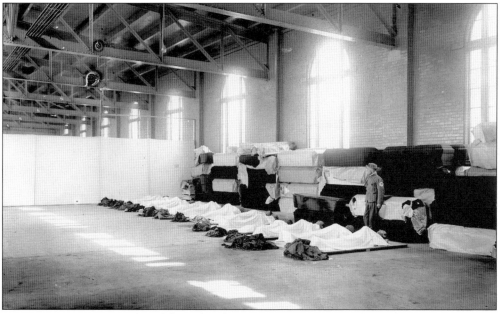

EMERGENCY MORGUE. One of the sad and gruesome necessities in the 1913 flood was burying the bodies of those who died from drowning, injury, or pestilence. Patterson, preparing for every eventuality, had the cavernous NCR garage converted to an emergency morgue. Coffins are stacked against the rear wall and mud-stained bundles of clothing and possessions are at the feet of each covered body. Note the guard standing watch.

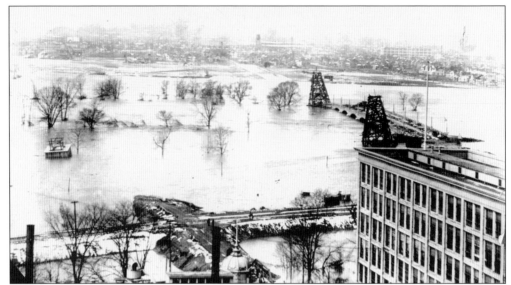

DAYTON STILL SURROUNDED BY WATER. Seen from atop one of the NCR buildings (another stands to the right), it is evident that all land and buildings, everything between the fairgrounds and Edgemont across the Great Miami River, is submerged. Still above water, however, are the railroad tracks and the road (bottom, just left of center) from NCR that gave the company access to the Miami and Erie Canal (in foreground), the tracks, and the river. The trestles at right were part of the Stewart Street Bridge, which was under construction at the time. Note the freshly fallen snow. (Courtesy of the Dayton Metro Library.)

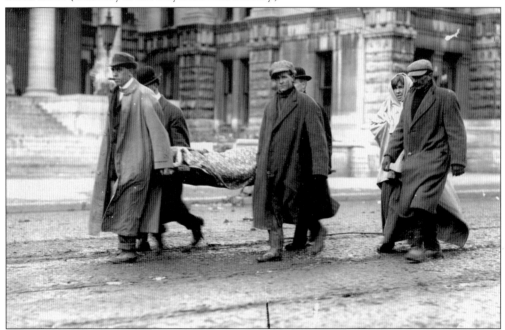

ANOTHER POSSIBLE FLOOD DEATH. Sad testimony that the emergency morgue might be needed is this group of four men carrying a flood victim past the Dayton courthouse at Main Street and Third Street. Walking behind them in the mud are another man and a woman, presumably members of the victim's family. (Courtesy of the Dayton Metro Library.)

Three
DEVASTATION

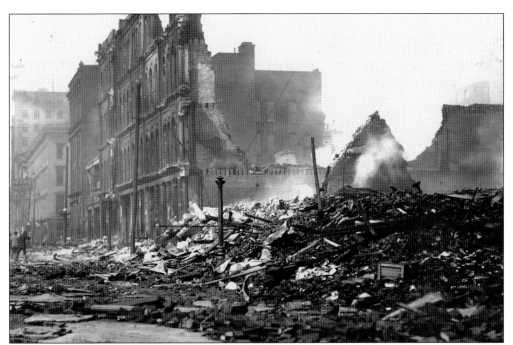

DOWNTOWN DAYTON IN ASHES. One of the ironies of flood is fire. The floodwaters rose so fast that gas mains could not be shut off. The first fire broke out at the corner of St. Clair and Third Streets shortly after dark on Tuesday night and rapidly spread westward. Workers trapped in office buildings actually had to clamber over the roofs of neighboring buildings to seek shelter from the encroaching flames. By week's end when the flood eventually receded, the northwest side of East Third Street between Jefferson Street and St. Clair Street was still smoldering. (Courtesy of the Dayton Metro Library.)

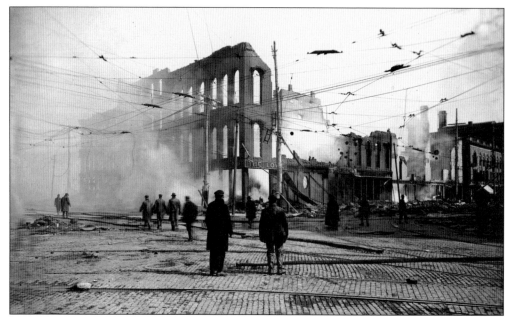

WATCHING HELPLESSLY. Standing among trolley tracks and laid-out fire hoses, citizens of Dayton watch the smoke rising from the ruins of the Lowe Paint Company on the southeast corner of East Third Street and Jefferson Street. Only facades stood, glassless windows gaping to the sky. The wires crisscrossing overhead provided electric power to the city's extensive system of trolleys. (Courtesy of the Dayton Metro Library.)

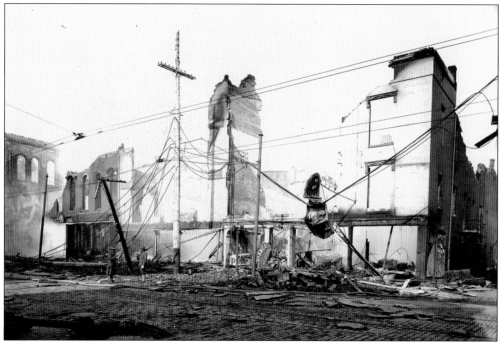

BUSINESSES DESTROYED. On the east side of Jefferson Street, businesses that were destroyed by fire included the Jewel Theater, the Western Union Telegraph Company, Huber Company, Kette Sons Company, and the Patterson Building. (Courtesy of the Dayton Metro Library.)

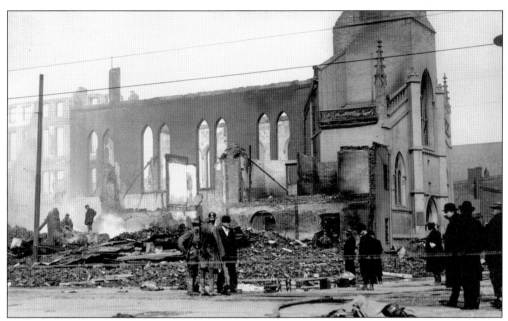

NOTHING SACRED. Even houses of worship were gutted by flood and fire. Only the stone walls were left of the still-smoking ruins of Park Presbyterian Church on St. Clair Street between Third and Second Streets. At center, a firefighter stands in his cloak and hat with his back to the camera, and a fire hose snakes over the pavement at lower right. (The light horizontal line across the lower portion of the photograph is a scratch on the negative.) (Courtesy of the Dayton Metro Library.)

STEELE HIGH SCHOOL. The powerful current of the floodwaters overtopping the levee at Monument Avenue and rounding the corner onto Main Street undermined the foundation under the west tower of Steele High School at the northwest corner of Monument Avenue and Main Street. At 9:00 a.m. on Wednesday, March 25, seven hours after high water, the entire tower collapsed. Several days later, after the water receded, the full damage was revealed. (Courtesy of the Dayton Metro Library.)

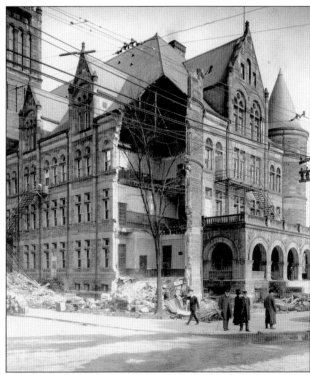

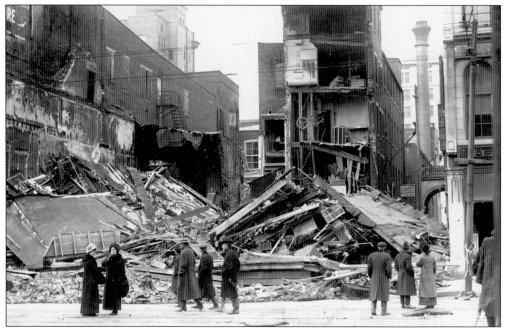

LEONARD BUILDING COLLAPSED. Due to the undermining force of the floodwaters, the entire Leonard Building on Main Street collapsed. That may have resulted from a fault in its construction, because the buildings on either side of it remained standing, and no other downtown building completely collapsed as a result of the flood. (Courtesy of the Dayton Metro Library.)

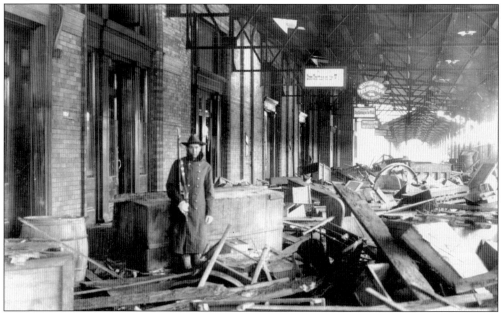

UNION STATION. At the passenger railway station union station depot, floodwaters had reached 10 to 12 feet deep. The train depot became the refuge of people trapped. After the floodwaters receded, its interior was a scene of devastation, its platforms covered with a deep, viscous ooze. Under martial law, a member of the Ohio National Guard was posted to prevent looting, as was also done elsewhere in Dayton's business district. (Courtesy of the Dayton Metro Library.)

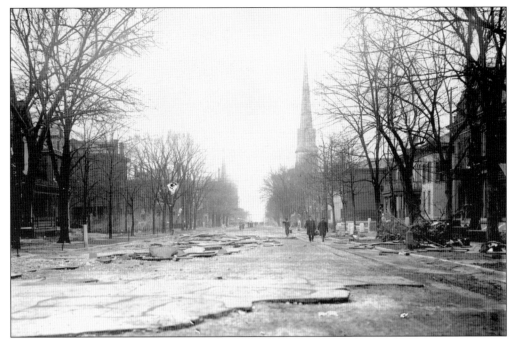

PAVEMENT TORN AWAY. The current of the flood was so strong it ripped off entire sheets of asphalt pavement from Ludlow Street (shown here) and First Street. (Courtesy of the Dayton Metro Library.)

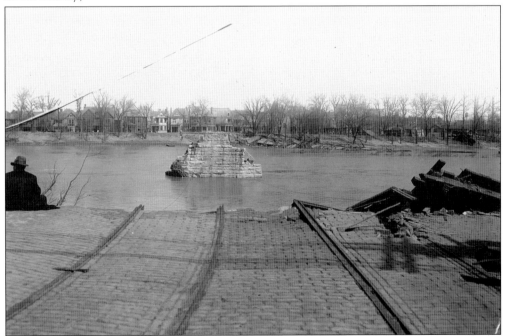

BRIDGES OUT. Steel bridges suffered worse than concrete or stone bridges. This one at Fifth Street was completely carried away by the torrential Great Miami River. Note the river's normal low level. (The diagonal line crossing the upper left corner of the photograph was a crack in the original 8-by-10-inch glass negative.) (Courtesy of the Miami Conservancy District.)

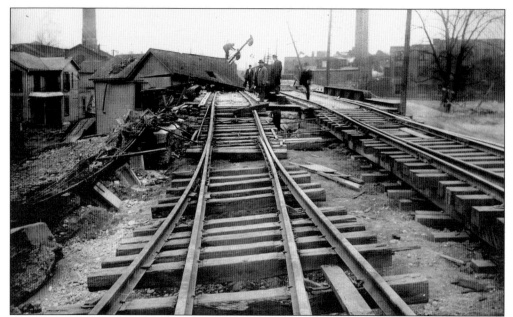

RAILROAD TRACKS TWISTED. Men inspect the wreckage of a building and a railroad signal, picking their way among splintered railroad ties and twisted rails—all evidence of the power of the floodwaters on the Lowie Street Bridge. On the right are the buildings of the Aetna Paper Company; the stack at the left belonged to the City Railway Company powerhouse. (Courtesy of the Dayton Metro Library.)

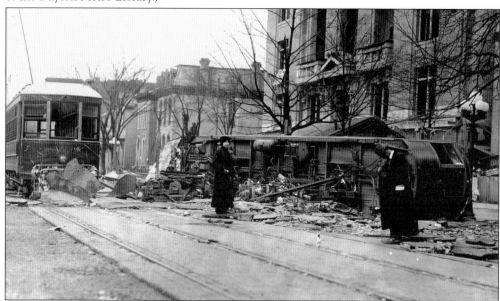

TRACTION CAR THROWN. The fierce current that swept around Third and Ludlow Streets was powerful enough to sweep a traction car off its rails and overturn it and shift it off the rails (the City Railway Company traction cars were part of Dayton's system of public transportation). Judging from the height of the five-globe streetlamp at the far right, the wrecked car would have been completely submerged. (The building in the background was the YMCA.) (Courtesy of the Dayton Metro Library.)

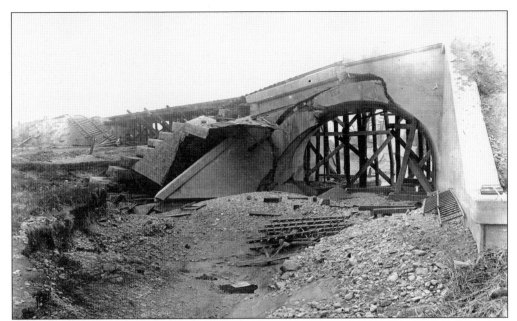

CAUSE OF FAILURE. Railway and highway bridges failed when the powerful floodwaters simply scoured away all the rock, soil, and gravel supporting the foundations of bridges, as happened here with the Big Four railroad crossing south of Dayton. Note not only the cracked concrete of the arch at right, but the twisted railroad track in the distance at left. (Courtesy of the Miami Conservancy District.)

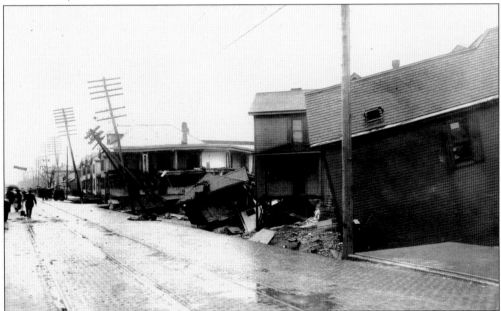

HITS TO UTILITIES. The eroding force of the floodwaters was tremendous. In this unidentified area, the ground was scoured away from foundations, leaving buildings tilted and twisted. The removal of so much supporting soil also toppled telephone and power poles and wires, posing a daunting recovery task for utilities. Unseen underground is additional damage to water mains, sewers, and gas lines. (Courtesy of the Miami Conservancy District.)

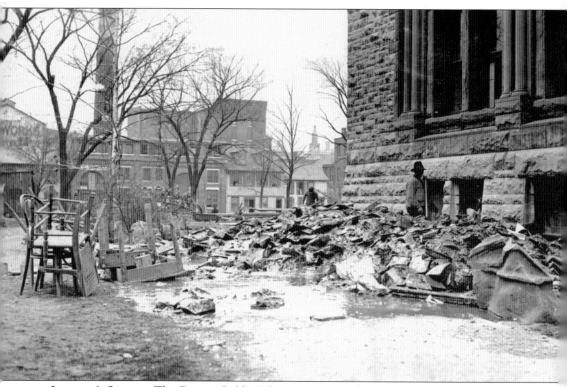

LIBRARY'S LOSSES. The Dayton Public Library on West Third Street between St. Clair Street and the Miami and Erie Canal lost more than 45,000 books—nearly half its collection—to the flood. On Tuesday and Wednesday, April 2 and 3, some 40 wagonloads of ruined books were shoveled and wheelbarrowed out of the library by a team of 13 rubber-booted gardeners from NCR offering gratuitous services to the city. (Courtesy of the Dayton Metro Library.)

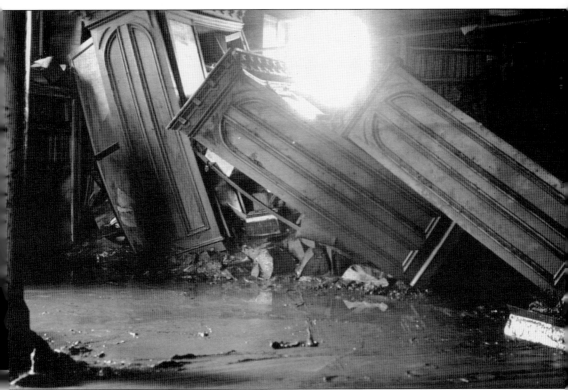

BASEMENT ROOMS AT A TOTAL LOSS. Floodwaters pouring in through broken windows reached 16 feet in the library, filling the entire basement plus four feet on the first floor. Shelves not completely filled were swept clean of books. On shelves completely filled, the waterlogged books swelled so much that they pushed out the walls of the walnut bookcases, so books had to be forced out with a crowbar. Some of the top-heavy bookcases fell over like dominoes. (Courtesy of the Dayton Metro Library.)

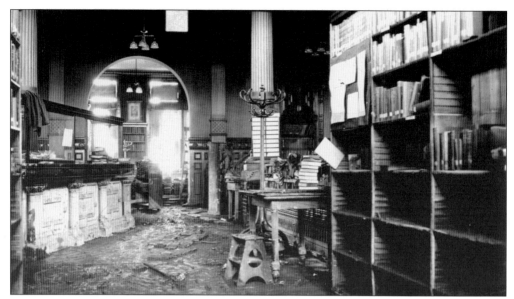

DELIVERY AND READING ROOMS. On the first floor, the floodwaters cleared the bottom four shelves of most bookcases (far right and left). Bookcases, desks, books, and the floor alike were coated with up to six inches of sticky, slimy, stinking mud. Amazingly, most of the card catalog remained readable. (Courtesy of the Dayton Metro Library.)

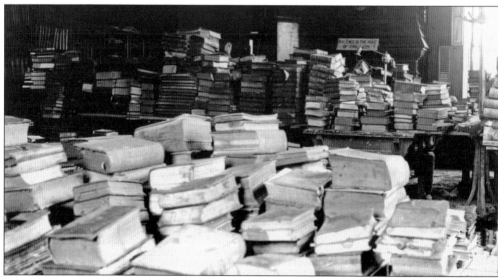

DRYING BOOKS. Even as the librarians and various volunteers were cleaning the library building, they were also setting books out on every clean horizontal surface to dry. Unceasingly turning pages, by day throwing open the windows to admit sunshine and dry outdoor air and by night running the furnace at full blast, they were able to salvage some 2,500 of the most valuable books. (The sign on the far wall reads, "Silence is the rule of this room.") (Courtesy of the Dayton Metro Library.)

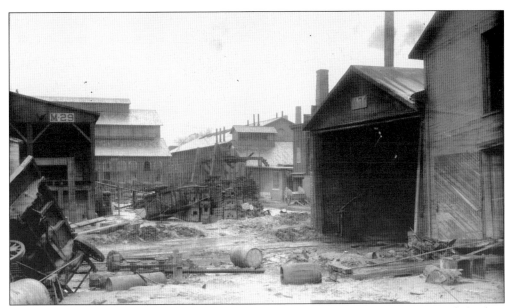

OUT OF BUSINESS. The Barney and Smith Car Shops on Keowee Street, a nationwide leading manufacturer of railroad cars headquartered in Dayton, was so financially injured by the flood that it went into receivership. Buildings of its manufacturing company were coated inside and out with thick mud, as were its yards and its manufacturing machinery. Barney and Smith may have been the single largest corporate sufferer in Dayton, with losses estimated to be between $800,000 and $1 million. (Courtesy of the Miami Conservancy District.)

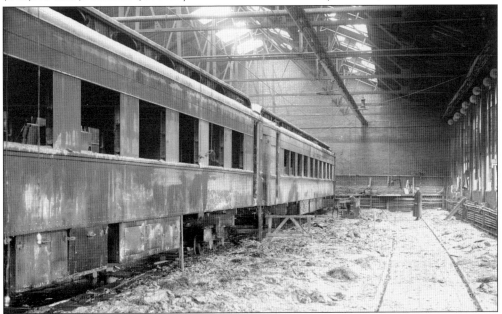

TWENTY LUXURY COACHES RUINED. One of the biggest blows to Barney and Smith was the loss of 20 fine mahogany coach cars that the company had just completed for the Canadian Pacific Railroad, estimated at $20,000 apiece. Many partially completed freight cars were also ruined. Note the dried mud coating everything inside this sky-lit warehouse. (Courtesy of the NCR Archive at Dayton History.)

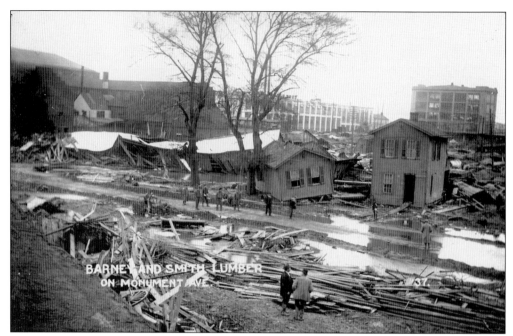

LUMBER SCATTERED. The Barney and Smith lumberyard on Monument Avenue was also hard hit, with its buildings shifted or collapsed and its lumber splintered and dispersed over square blocks. Some of the lumber was of costly fine wood, such as mahogany, used for finishing luxury coach railroad cars. (Courtesy of the Dayton Metro Library.)

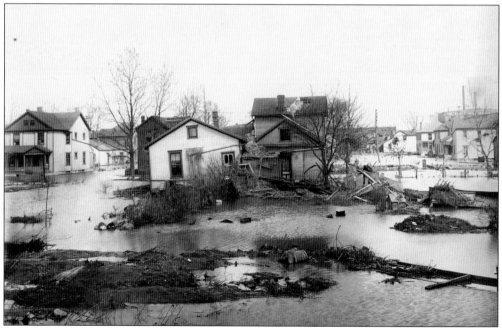

NORTH DAYTON DESTROYED. North Dayton, near the Webster Street Bridge over the Mad River, suffered among the first and worst. Note the hole in the roof of the house just right of center, where people trapped in their attic may have attempted to escape onto the roof. (Courtesy of the Miami Conservancy District.)

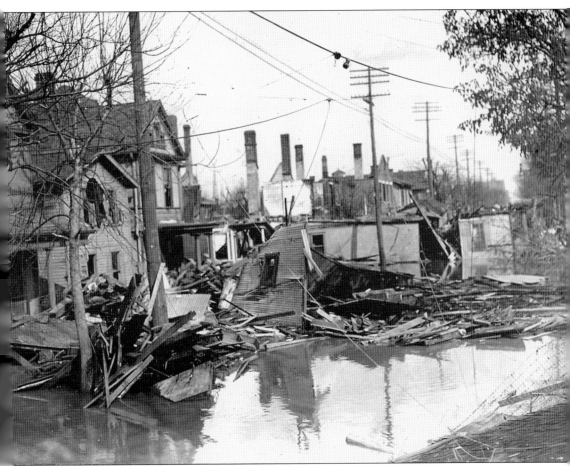

MAPLE STREET LOOKING EAST. Above the debris clogging the roadway, flood victims returning home would have seen the roofless chimneys mutely attesting to the fact that their houses were ruined. (Courtesy of the Miami Conservancy District.)

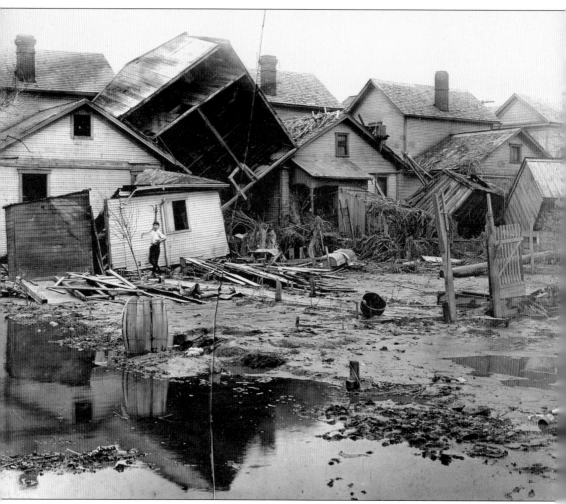

WHERE IS HOME? In some regions, cottages were tossed like children's blocks and left tumbled on top of neighbors' houses, everything coated with thick, sticky filth. (Courtesy of the Miami Conservancy District.)

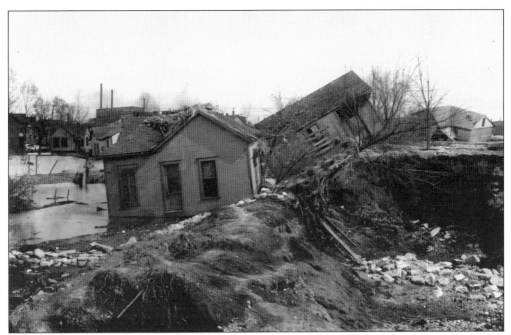

LOCATION, LOCATION, LOCATION. Some people needed to search for their homes because the floodwaters had deposited them elsewhere. Many homes were found washed up against the eroded levees, such as these below the Herman Avenue Bridge in North Dayton. (Courtesy of the Miami Conservancy District.)

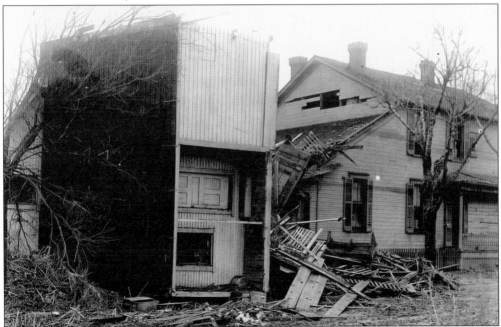

UPENDED HOUSE. Where does one start to recover when the floodwaters have completely ripped one's house from its foundations and canted it sideways? In the neighboring house to the right, note the slats missing from the attic, possibly where its residents escaped to safety. (Courtesy of the Miami Conservancy District.)

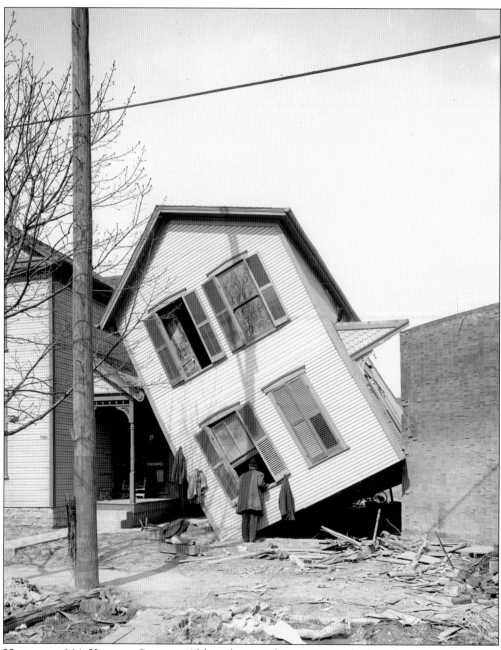

HOME AT 664 KEOWEE STREET. Although some homes were tilted "only" a little bit away from plumb, how would one return this wedged home to correct orientation on its foundation? (Courtesy of the Dayton Metro Library.)

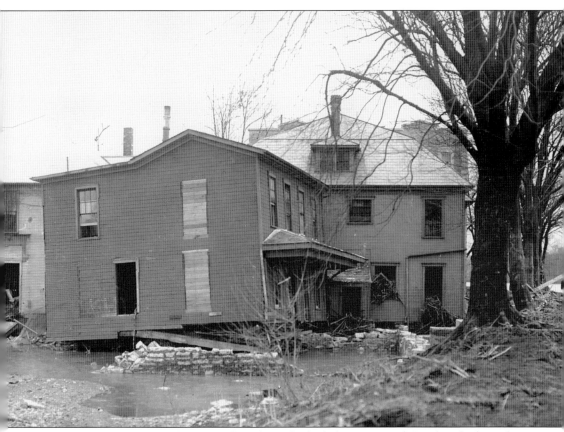

ALMOST DEVASTATED. Some homes at first glance looked almost normal. But hundreds, such as this one at an unidentified location along the south side of the Great Miami River, had been shifted bodily several feet off their foundations. (Courtesy of the Miami Conservancy District.)

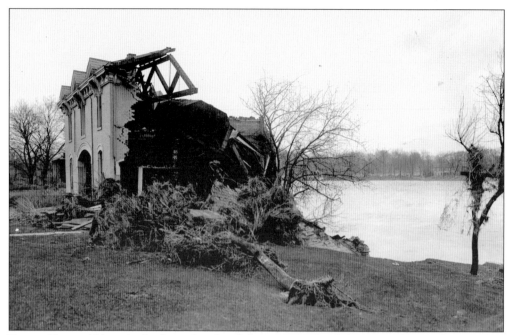

RIVER VIEW. Although the front facade of this gracious brick home at the northern end of Ludlow Street appears intact, the collapse of a retaining wall along the Great Miami River caused the entire back end of the house to cave in. Adding insult to injury was the uprooting of an ornamental tree. (Courtesy of the Miami Conservancy District.)

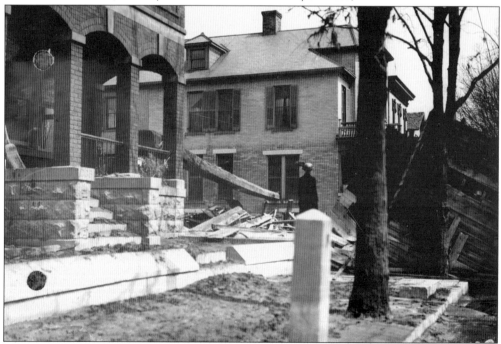

TRICKS FLOODS PLAY. Of many freakish occurrences during the 1913 flood, a most remarkable one was the wedging of a bridge girder a foot on a side and 75 feet long between two houses on West Monument Avenue. (Courtesy of the Dayton Metro Library.)

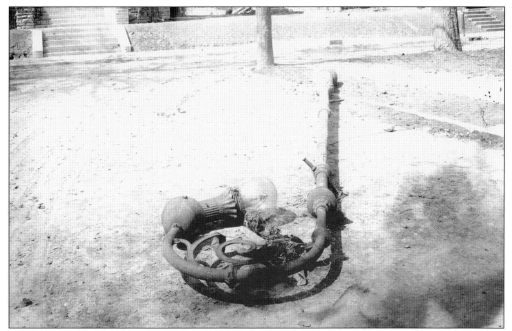

DELICACY AMID VIOLENCE. At the corner of Robert Boulevard and Sycamore Street, the floodwaters in all their power and violence snapped off this lamppost—but somehow managed to deposit it onto the ground so gently that the glass lamp globe did not break. (Courtesy of the Miami Conservancy District.)

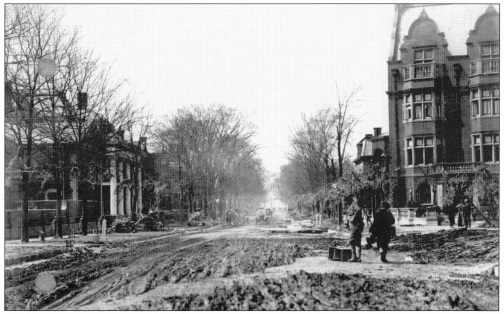

THICK, STINKING MUD. Coating everything—streets, exterior and interior walls, floors, and ceiling, and all household objects—was inches of thick mud. Frequently described as yellowish, it reeked with animal and even human feces from overturned privies, posing a major public health problem. In the buildings at right, note that the windows are missing from the first two floors, giving some idea of the floodwaters' peak height. (Courtesy of the Dayton Metro Library.)

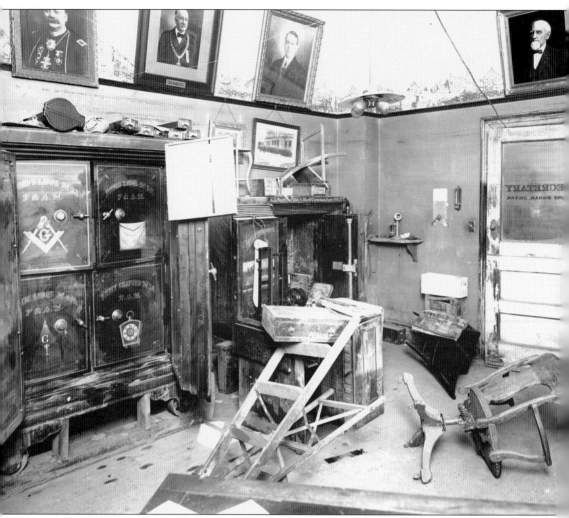

MUD-COATED OFFICES. The flood had filled not only the interiors of factory buildings but also the interiors of professional offices belonging to lawyers, doctors, and dentists. In this office, belonging to the secretary of the Masonic temple, muddy water had reached up to the bottom of the portraits. (Courtesy of the NCR Archive at Dayton History.)

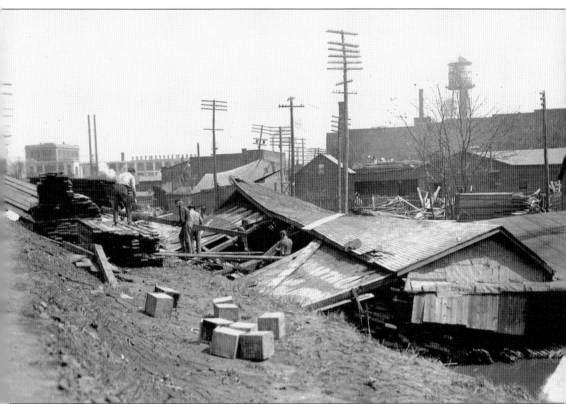

CANAL WORSENED FLOODING. The 1913 flood effectively sounded the death knell of the Miami and Erie Canal. Not only did the canal provide another waterway through the heart of Dayton, but the lumber choking it acted as a dam, causing the floodwaters to spread more widely through downtown than otherwise might have happened. After the floodwaters receded, the canal was all but invisible under the debris. The footpath at left may be the canal towpath. (Courtesy of the Miami Conservancy District.)

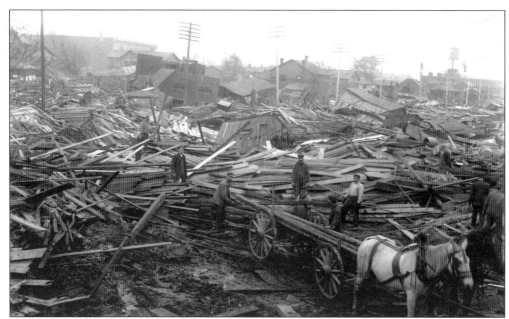

CANAL BURIED. Invisible under all the scattered lumber from nearby lumberyards is the Miami and Erie Canal. This view is looking southwest from the canal bed near Webster Street. On the right is part of Burkhart Furniture, and on the left is the Erie Freight Depot. Debris in the canal may have exacerbated flooding by damming the water and causing it to spread out. (Courtesy of the Dayton Metro Library.)

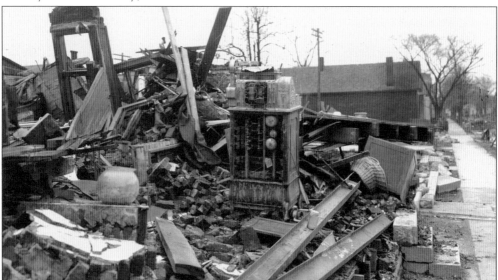

TRAGEDY IN THE RUBBLE. On Tuesday morning, as water began coursing past Ollie Saettel's grocery at Main and Vine Streets, a neighbor helped the store's owner take merchandise out of the store's cellar to its second floor. But their labor proved to be in vain. Hours after the neighbor was rowed back to his house, an explosion in the store's basement blasted through the roof and walls. Saettel's 75-year-old father was thrown onto a floating roof, which eventually sank. Atop the rubble, the engraved metal object (with what look like doorbells inside it) may be the store's cash register. (Courtesy of the Miami Conservancy District.)

Four

RELIEF

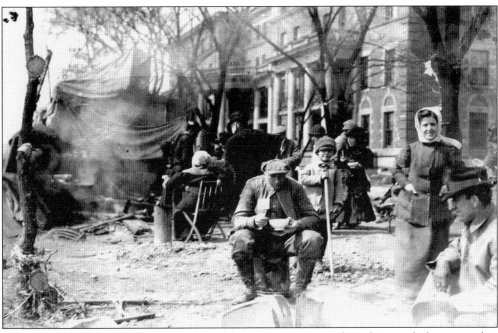

LEFT WITH NOTHING. Dayton's 1913 flood left many victims with no house, clothing, or other possessions. In that era before widespread use of homeowners' or flood insurance, such losses meant financial destitution even to citizens who practiced lifelong thrift. Yet somehow, even when squatting amid the muck around a cooking fire on the northeast corner of Main and Stillwater Streets before the Bellevue Apartments, men and women reunited with their children could smile. (Courtesy of the Dayton Metro Library.)

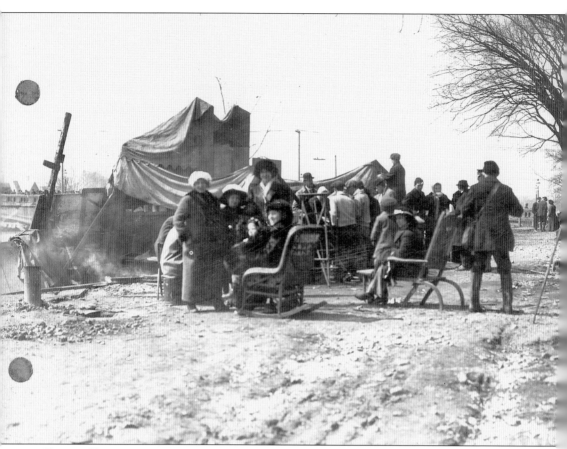

FLOOD VICTIMS ALONG THE RIVER. With some unbroken furniture salvaged and with improvised shelters, those left homeless congregated in informal refugee camps. Yet even in their mean surroundings—especially significant in an era when camera snapshots were still not common and those photographed often kept their faces sober—some faces wore broad smiles. The dark circles on the left are punches through the photographic print. (Courtesy of the Dayton Metro Library.)

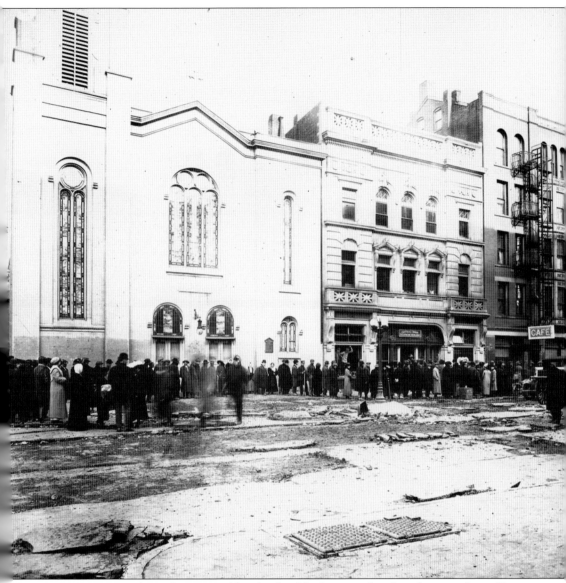

WAITING IN LINE. Those dispossessed by the flood had to stand in line for everything. Here citizens are lined up in front of the Central Union Telephone Company's main Dayton exchange (middle building) on the east side of Ludlow Street between Second and Third Streets to obtain military emergency passes. The left building is the First Reformed Church; the darkened area up to the top of the entrance doors shows the depth of the floodwaters. (Courtesy of the Dayton Metro Library.)

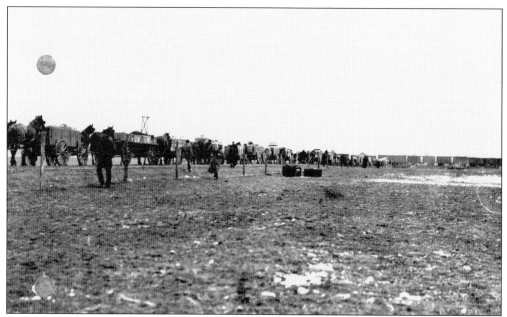

RELIEF TRAIN. As soon as the waters receded enough—and tracks were repaired—to resume rail service, food, blankets, and other necessities donated by people and agencies around the nation began to arrive by train (background right). The trains were met by scores of horse-drawn wagons (lined up at left) that hauled the supplies into Dayton to be distributed by the Citizens' Relief Committee or the militia. (Courtesy of the Dayton Metro Library.)

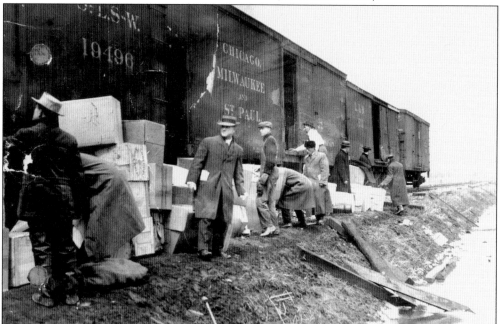

BOXCARS OF RELIEF. Barrels, bales, and boxes of foodstuffs, blankets, and other supplies arrived from cities all around the nation. Also brought on the relief trains were medical personnel and such skilled workers as carpenters and mechanics, plus 300,000 rations from the federal government. (Courtesy of the Dayton Metro Library.)

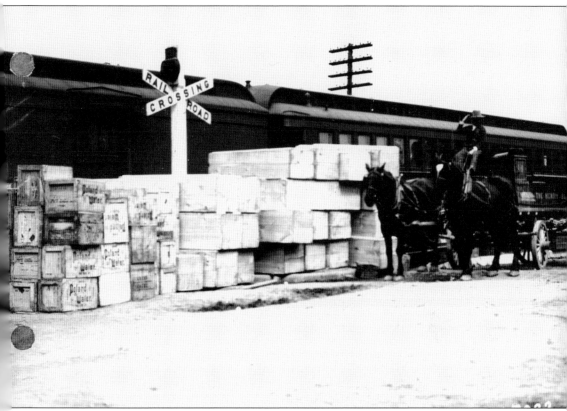

WATER TO THE FLOOD. Despite Dayton's inundation by billions of gallons of water, none of it was drinkable. By Tuesday, April 1, the water treatment plants had been drained of the muddy water and were repaired enough to operate. Even so, many underground water mains and pipes had been broken. Thus, relief supplies sent to Dayton included bottled Poland Water (wooden crates at left). (Courtesy of the Dayton Metro Library.)

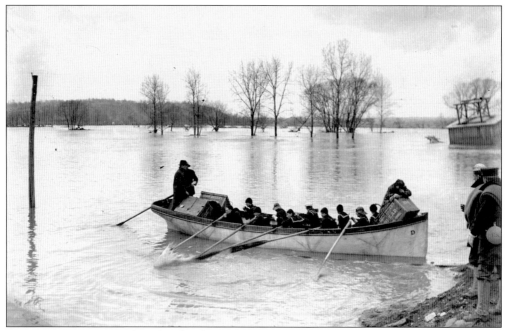

SUPPLIES BY BOAT. Before the floodwaters had fully subsided, the water itself helped carry supplies—in this case, crates of bread from Deger's Bakery. Here a dozen "blue jackets" from the Lake Erie U.S. Marines land a boat, likely at the rail/boat access area just below NCR. (Courtesy of the Miami Conservancy District.)

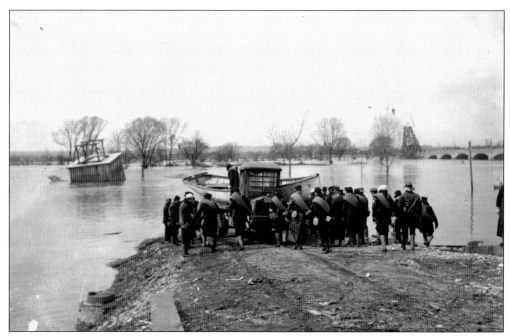

MISSION OF MERCY. Minutes after the photograph above, the marines are loading the crates into a waiting car to take the bread to St. Elizabeth's Hospital. (Courtesy of the Miami Conservancy District.)

MAJ. THOMAS L. RHOADS. Pres. Woodrow Wilson placed Maj. Thomas L. Rhoads, head of the U.S. Army's Medical Corps and Wilson's own private physician, at the disposal of Dayton. So Rhoads traveled from Washington, D.C., and was placed in charge of Dayton's sanitary rehabilitation reporting to Brig. Gen. George H. Wood, who commanded the Dayton Military District. (Courtesy of the Dayton Metro Library.)

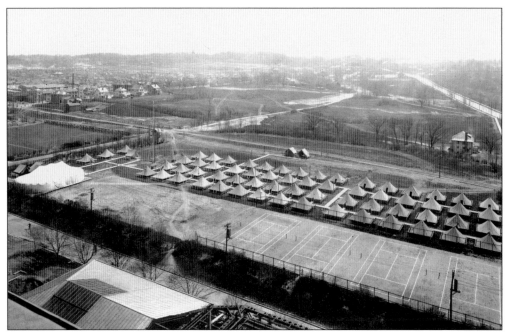

CAMP RHOADS. This aerial view is of the neat and orderly refugee camp of at least 60 conical tents built on the high ground of NCR next to the tennis courts. It became known as Camp Rhoads after its organizer, sanitary expert Maj. Thomas L. Rhoads, Medical Corps, U.S. Army. (Courtesy of the Dayton Metro Library.)

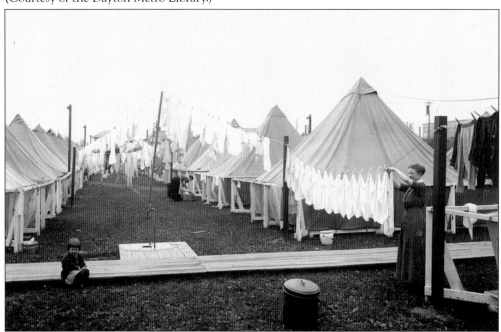

WASH DAY AT CAMP RHOADS. Almost two months after the flood, toward the end of May, Dayton citizens whose homes had been destroyed by the flood were still living in tents. Life went on. While men were reconstructing their houses and earning a living, women were making a home as best they could. (Courtesy of the NCR Archive at Dayton History.)

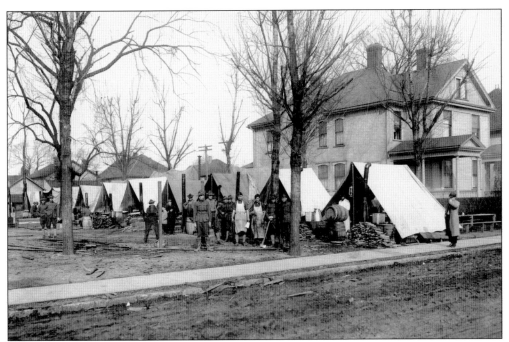

MILITIA CAMP. Tents for several companies of the Ohio National Guard were set up in the Franklin School yards at the intersection of Findlay and Fifth Streets. The cook tent is the one with the stovepipe, the first tent next to the sidewalk. (Courtesy of the Dayton Metro Library.)

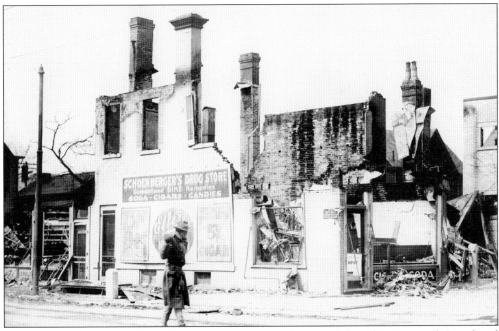

PREVENTING LOOTING. One of the most important missions of the Ohio National Guard and other militia was patrolling businesses and homes to prevent looting. This soldier is passing the charred remains of Schoenberger's Drug Store at the southeast corner of Fifth and Jefferson Streets. (Courtesy of the Dayton Metro Library.)

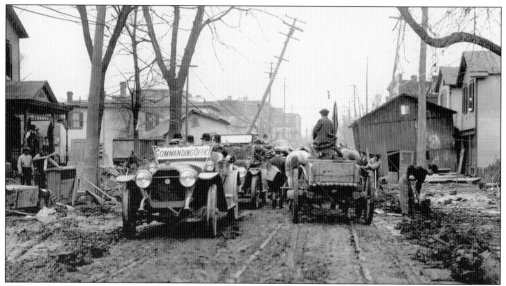

INSPECTION TOUR. Gen. George H. Wood, commanding officer for flood relief operations, and his entourage—which included John H. Patterson (second derby from left) as well as his right-hand man, NCR general manager Edward A. Deeds (derby at far left, speaking)—drove through the muddy streets inspecting the consequences of the flooding and the progress of cleanup. After several such tours of inspection around Ohio, Patterson became convinced that Dayton suffered the greatest loss of any city in Ohio, both in terms of property and proportion of affected population. (Courtesy of the Dayton Metro Library.)

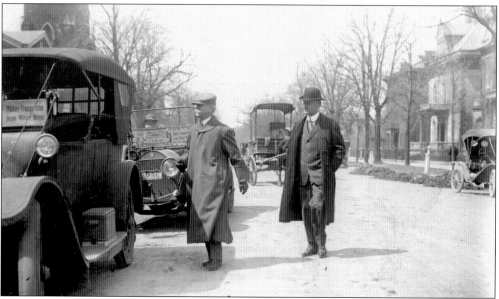

DEEDS FOLLOWING PATTERSON. Edward A. Deeds, who after Patterson's death eventually became president of NCR, also helped cofound Delco (with NCR engineer Charles Kettering) and the Wright Airplane Company (with Orville Wright and Kettering, and another). In the years after the 1913 flood, Deeds also spearheaded efforts to protect Dayton permanently from future floods (among other things, allowing the use of his home's swimming pool to test innovative flood-protection technologies). (Courtesy of the Dayton Metro Library.)

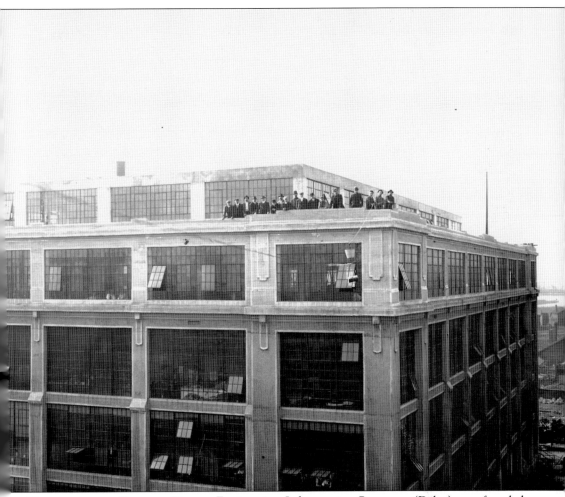

DELCO TO THE RESCUE. Dayton Engineering Laboratories Company (Delco) was founded in 1909 by Deeds and former NCR product design engineer and inventive genius Charles Kettering, who invented the electric starter to replace the hand crank of automobiles. When the floodwaters breached the levee early Tuesday morning, March 25, already 43 men were at work in the Delco plant on East First Street. Although marooned themselves, from second-floor windows, they rescued about 30 people who were being borne past on pieces of wreckage. Undeterred by the torrential downpour, they found their way across adjoining roofs to find food and ground coffee. With electricity from a generator run by hooking an automobile engine to a dynamo, the Delco employees brewed coffee and cooked food for themselves and the people they had rescued. Moreover, using cables (faintly visible in the photograph extending to the left foreground from the hands of men in the right corner), they rigged a wire trolley across several streets and buildings to ferry meals and hot coffee to hundreds of people trapped in neighboring buildings. (Courtesy of the Dayton Metro Library.)

PUMPING OUT FLOODWATER. At the Delco plant, the floodwater had been 17 or 18 feet deep on the sidewalk, filling the basement and first floor with water and inches of slimy silt. After the flood receded, Delco borrowed several fire engines for pumping the muddy water out of the basement and turned the full force of clean water onto the factory machinery in the basement to clean it. Fire hoses were also used to clean the outside of the factory. Miraculously few windows had been broken, in part because freight cars from a nearby rail yard had washed up against the factory, protecting its lower walls from the flood's full force. Note the canoe on the sidewalk. (Courtesy of the Dayton Metro Library.)

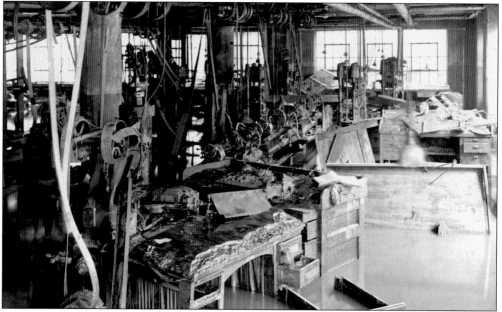

OOZE AND SLIME. Even after two days and two nights of pumping water out of Delco's basement Bakelite room at the rate of 1,700 gallons per minute, floodwater was still knee-deep. Note the layers of mud inches deep coating the top of the desk in the foreground. Floodwater had actually reached nearly up to the ceiling (darker division on the pole in the foreground is painted). (Courtesy of the Dayton Metro Library.)

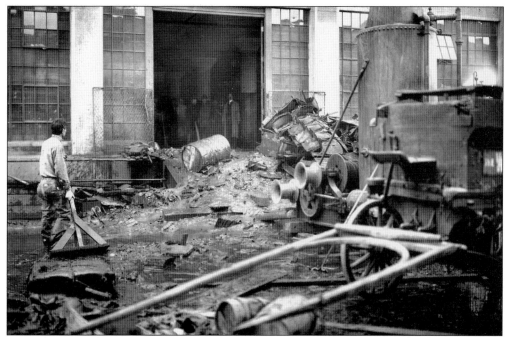

MUCK HAD TO GO SOMEWHERE. Delco employees used huge wooden scrapers built like push brooms to get the mud and debris out of the first floor of the plant. (Courtesy of the Dayton Metro Library.)

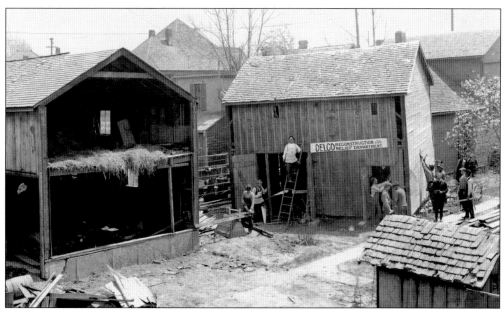

RECONSTRUCTING EMPLOYEES' HOMES. Out of more than 1,000 Delco employees, some 200 who had owned their own houses were left homeless by the flood. So to get employees back to work as quickly as possible and free them from worry, Delco hired skilled workers to reconstruct their homes. The Delco reconstruction crew included house movers, foundation builders, carpenters, paperhangers, painters, and furniture repairmen. (Courtesy of the Dayton Metro Library.)

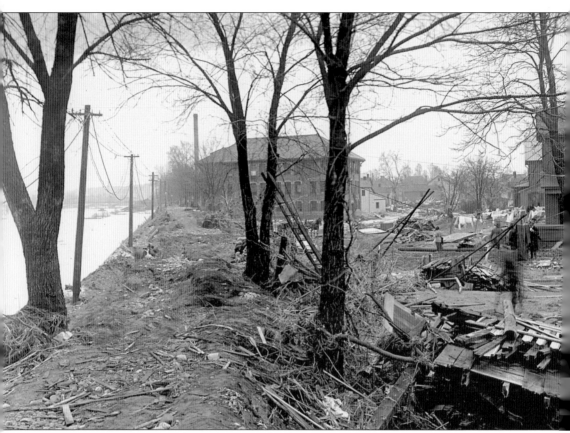

LIFE AMID WRECKAGE. Clean white laundry dances from clotheslines (far right) as men inspect the ruins of their homes to begin rebuilding. The Great Miami River flows well below the levee, which was on the river's west bank; the photographer was shooting south from a point directly below the Third Street Bridge. (Courtesy of the Miami Conservancy District.)

Five
Recovery and Renewal

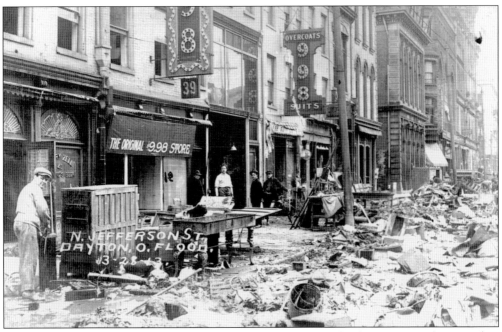

THE FIRST MORNING. The morning of Friday, March 28, was the first time people trapped in office buildings could escape and could pick their way through flood-strewn South Jefferson Street between Third and Fourth Streets since the levees had broken. Businesses at left (on the west side of the street) that can be identified are, from left to right, Henry Zell's Saloon, the E. J. Margolis Company, and the Margolis $9.98 Suit Company. Despite being surrounded by wreckage and filth, notice the smile on the face of the man at left. (Courtesy of the Dayton Metro Library.)

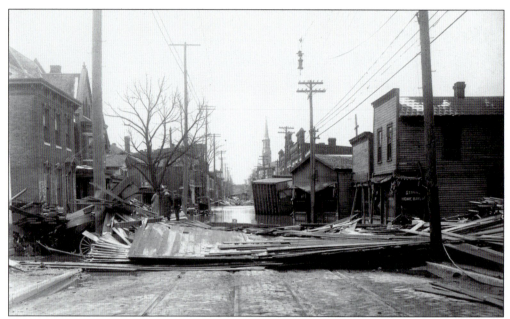

BLOCKED STREETS. After the floodwaters receded, cleaning the streets was a high priority so that people could return to homes and businesses. This mess on East Fifth Street, looking west from Clinton Street, showed the typical problem: streets were blocked not only by miscellaneous debris, but also by displaced sheds and buildings. The building at the far right is Strain's Home Bakery at 1227 East Fifth Street. (Courtesy of the Miami Conservancy District.)

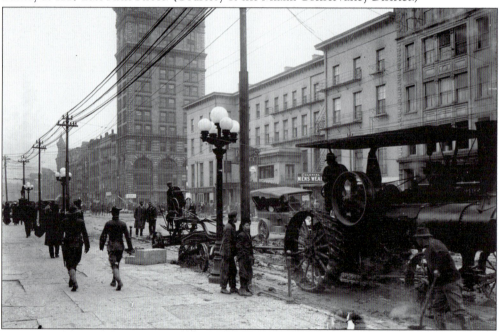

CLEANING THE STREETS. Business streets were cleaned by traction engines towing scrapers, as is shown here on Third Street west of Main Street. This photograph gives a good feel for the height of the floodwaters, which had come up to the lip at the neck of the five-globe streetlamp. (Courtesy of the Miami Conservancy District.)

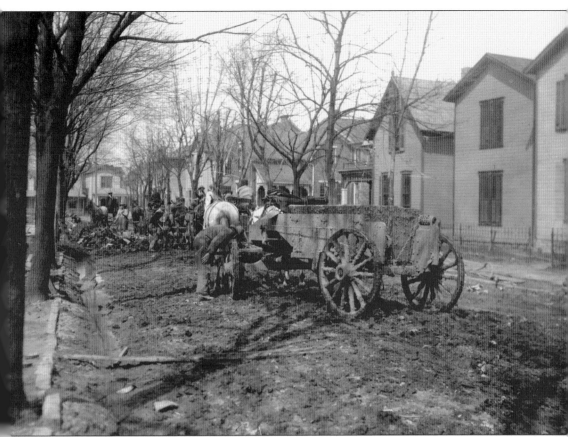

WAGONLOADS OF MUD. In residential areas, the mud deposited by the floodwaters was shoveled into wagons pulled away by horses, as on this unidentified street. Note how the mud clings to the wheels and sides of the nearest wagon. According to the official report by Maj. Thomas L. Rhoads, altogether some 135,000 wagonloads of flood refuse were hauled out of Dayton to dumps. (Courtesy of the Dayton Metro Library.)

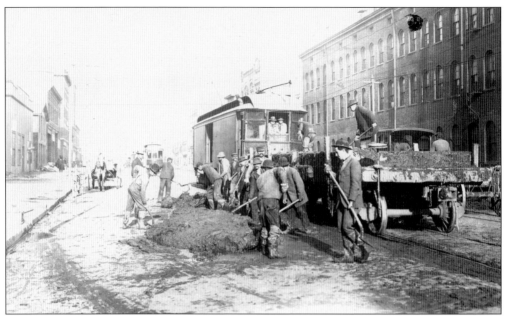

TRAINLOADS OF MUD. So thick was the mud that in the business district it was dumped into railroad flatcars that were rolled downtown on the trolley tracks, as shown here on East First Street. Flatcars could haul away a far greater volume faster than horses and wagons. Moreover, 58 railway cars of powdered lime and other disinfectants were distributed in Dayton for sanitizing streets, houses, and office buildings. (Courtesy of the Dayton Metro Library.)

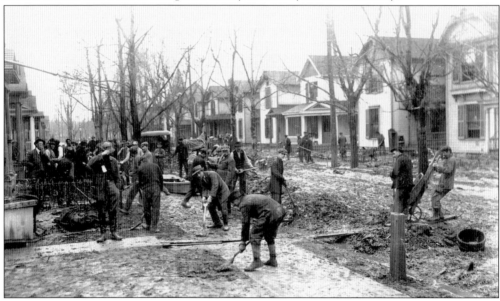

IMPORTED LABOR. Many of these men shoveling muck may have come from outside Dayton. Because labor in booming industrial Dayton was always in short supply, and was especially so after the flood, over the next few weeks, the city imported several thousand common laborers from other cities to help with the cleanup. A point was made of screening their backgrounds to ensure they were not criminals and would make good citizens in the recovering city. (Courtesy of the Dayton Metro Library.)

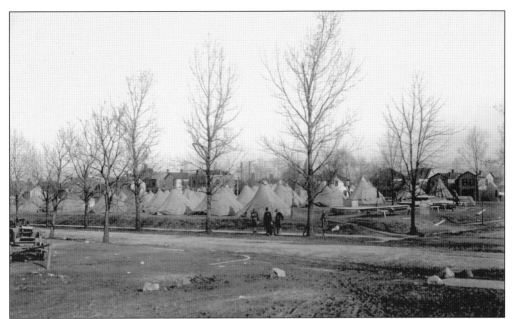

LABOR CAMP. The imported laborers were housed in another tent city on the grounds of the Bonebrake Theological Seminary (then for the United Brethren denomination) at First Street and Euclid Avenue. The tents for the laborers looked distinctly different from those either at Camp Rhoads for flood sufferers or at the military camps for the National Guard, the army, and other militia. (Courtesy of the Dayton Metro Library.)

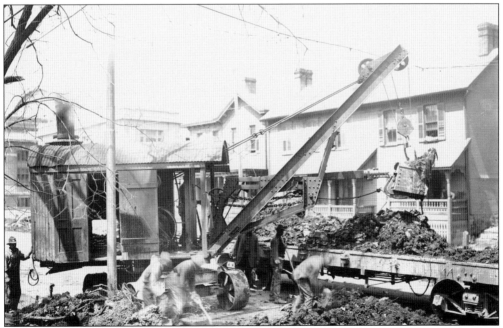

PRIMITIVE CRANE. Streets were cleaned by machines as well as men, especially where flood deposits were thick or large. Here along East Monument Avenue, possibly in front of Memorial Hall, an early version of a crane lifts muck and debris onto a flatbed railway car. (Courtesy of the Dayton Metro Library.)

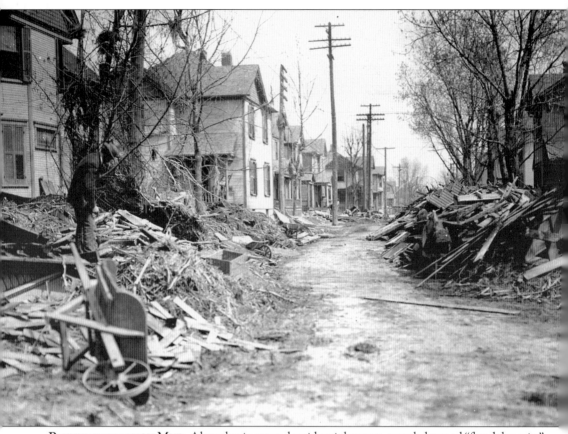

PATHWAY THROUGH MUD. Along business and residential streets, people heaped "flood deposits" of mud and debris along the curbs, allowing access down the middle of the streets. This street is Herman Avenue near Hunter Street. (Courtesy of the Miami Conservancy District.)

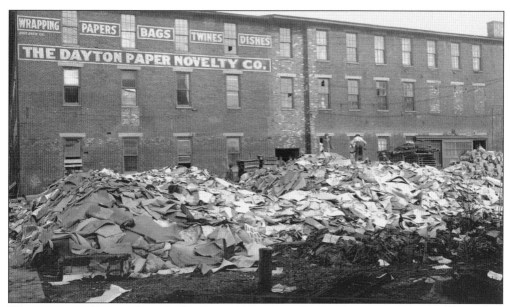

WATERLOGGED PAPER. Outside the Dayton Paper Novelty Company, at 1126–1200 East Third Street, every roll and sheet of paper stock soaked or splattered by the floodwaters had to be discarded—a volume of wood pulp nearly as high as a man (note men in the background near the building). Judging from the dark staining especially visible on the brick facade at left, the floodwaters may have reached the middle of the second story. (Courtesy of the Dayton Metro Library.)

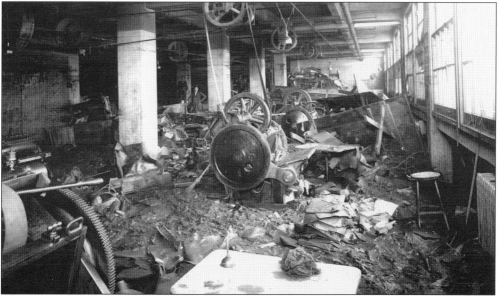

OIL THAT MACHINERY! Forget the mess on the floor, save the machinery that runs the company. This photograph, taken inside a lower floor of the Dayton Paper Novelty Company, appears to have surprised a couple of men (left rear of room) in their cleaning and lubrication of massive gearing (note the oilcan on the desk in the foreground). From stains on the walls and pillars, it appears as though the floodwaters had reached within a few feet of the ceiling. (Courtesy of the Miami Conservancy District.)

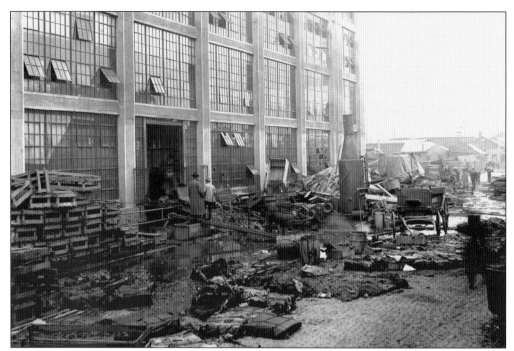

CLEANING DELCO. In a scene strikingly similar to the cleanup outside the Dayton Paper Novelty Company, men shovel mud and muck out from the first floor of the Delco factory on East First Street. (Courtesy of the Dayton Metro Library.)

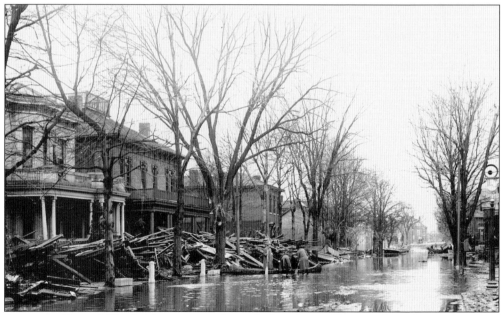

ANOTHER FLOOD? Flood debris was neatly stacked in front of houses along the south side of Monument Avenue looking west from Main Street, a task requiring a canoe. This photograph may have been taken in early April, when more heavy rains lasting several days alarmed the citizens of Dayton about the possibility of a second major flood—which, to their relief, did not occur. (Courtesy of the Dayton Metro Library.)

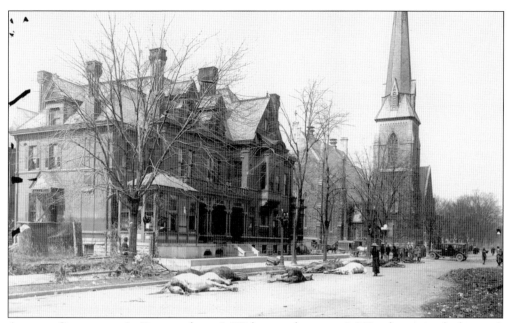

ANIMAL CARCASSES. In Dayton alone, 1,420 horses plus some 2,000 other animals drowned, according to the official tally of Maj. Thomas L. Rhoads in mid-April. When the floodwaters receded, their carcasses littered the streets, such as here on North Ludlow Street near Second Street. The thousands of carcasses were hauled away and burned. The steeple on the northwest corner belongs to First Presbyterian Church. (Courtesy of the Miami Conservancy District.)

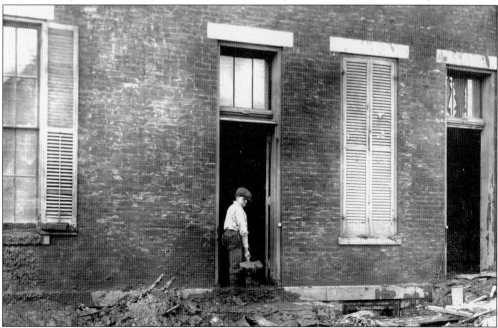

SHOVELING THE MUCK. The floodwaters left behind a slimy, penetrating silt that ranged from yellowish to brown to black. It coated absolutely everything, inside and out, as high as the floodwaters reached. Here a boy shovels mud out of his brick home. (Courtesy of the Dayton Metro Library.)

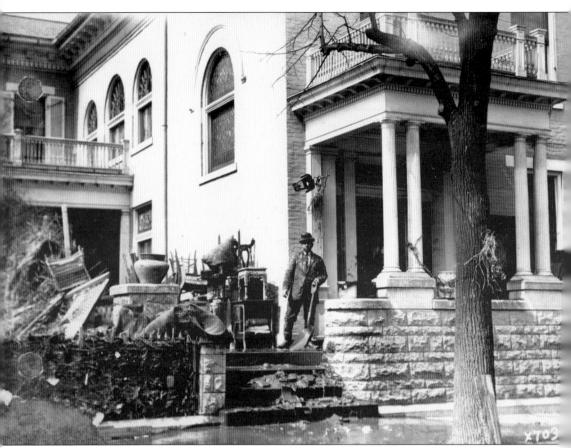

RICH AS WELL AS POOR. Mud infiltrated the mansions of the Dayton's wealthy as well as the cottages of the poor. Holding a snow shovel, the man in the center (next to the furniture airing out) is covered with mud from pant legs to hat. (Courtesy of the Dayton Metro Library.)

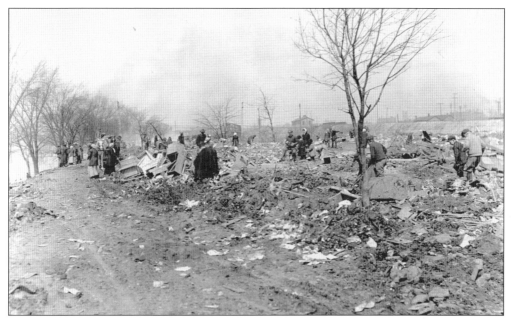

PICKING UP THE PIECES. The flood scattered the possessions of thousands of flood victims across the countryside. The only way to find anything was to search every square inch. Under martial law, strict orders were issued against looting, declaring that salvaged objects and materials were the property not of the finder, but of the lawful owner. (Courtesy of the Dayton Metro Library.)

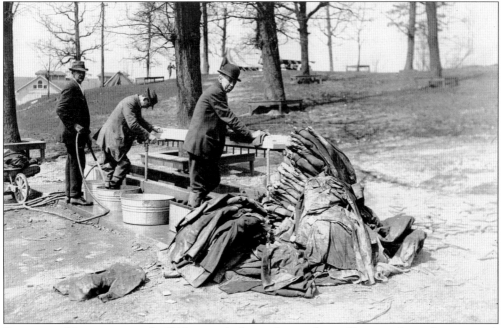

SALVAGING MERCHANDISE. In 1913, an era before widespread use of business-loss or homeowner's insurance, people could not afford to discard anything that could be salvaged. Clothing merchants clean their damaged stock by washing flood-stained new suits in tubs at the fairgrounds and then hanging them to dry. (Courtesy of the Dayton Metro Library.)

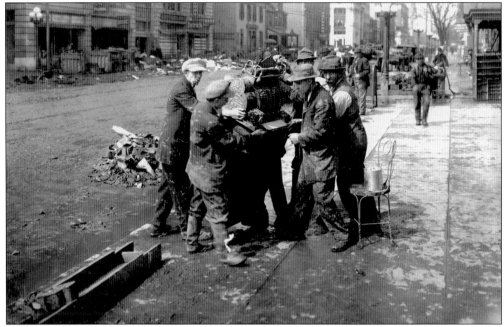

SALVAGING CASH REGISTER. Half a dozen shopkeepers struggle to clean a cash register (possibly one by NCR) on South Ludlow Street. Note how all are stained with mud even up to the shoulders. Note also the oilcan resting on the nearby chair. In the background, flood deposits of mud and debris line both sides of the street. (Courtesy of the Dayton Metro Library.)

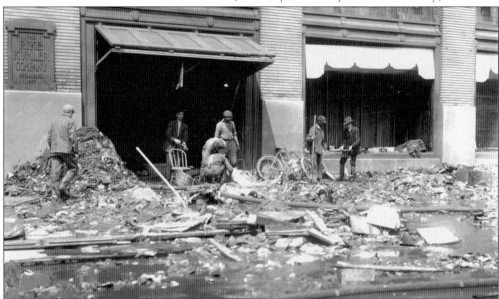

STARTING OVER. The display windows on the Second Street side of the department store Rike Kumler, like those of countless other retail businesses ranging from clothing to automobiles, were shattered by the force of the floodwaters, and the contents were swept into the street. Rike Kumler actually fared better than some stores during the flood, because on Thursday, March 27, Adj. Gen. George H. Wood bought the entire contents of the store for the State of Ohio so as to have supplies to issue to flood victims. (Courtesy of the Dayton Metro Library.)

FORCED TO VACATE. The flood forced some businesses to close, such as these on the east side of South Main Street between Fourth and Fifth Streets. But remarkably, such pessimism in Dayton after the flood seemed to be more an exception than the rule. (Courtesy of the Dayton Metro Library.)

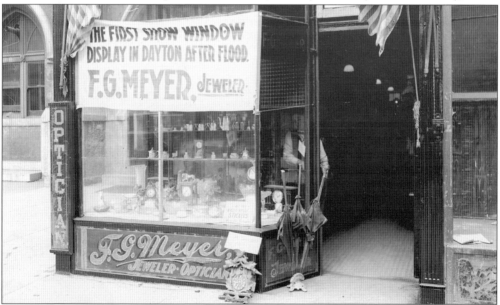

FIRST DISPLAY WINDOW. "The first show window display in Dayton after flood," announced F. G. Meyer, jeweler, after cleaning and restoring the shop. The cheery sign hid some harrowing facts. The floodwaters had washed tens of thousands of dollars of necklaces, rings, and other jewels into Dayton's streets and gutters. It was one task of the National Guard to recover the valuables, especially between midnight and dawn on Friday, March 28, as soon as the water receded to the railway line, and before citizens trapped in office buildings could leave for the first time in three days. (Courtesy of the NCR Archive at Dayton History.)

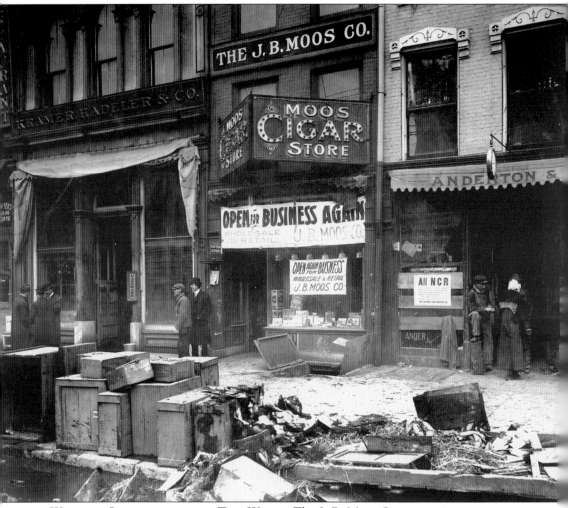

WINDOWS INSTALLED WITHIN TWO WEEKS. The J. B. Moos Company cigar store was open for business by early April. The sign on the neighboring window reads, "All NCR Tool makers, Pattern makers, Model makers and Draftsmen report for work At Once at your respective Departments. All other employes [sic] report Monday morning, April 7th. The National Cash Register Co." For weeks, such public notices were a primary method of communication. (Courtesy of the Dayton Metro Library.)

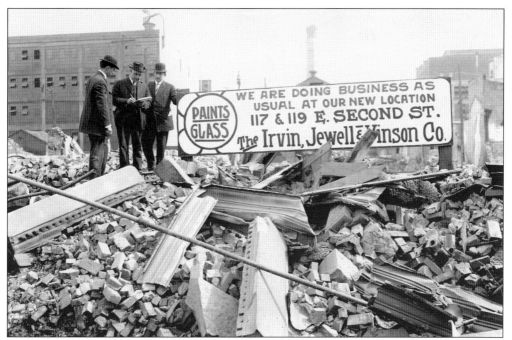

TAKING ORDERS. Even minus a storefront, merchants found a way to keep business going—and demand was heavy in the construction trades. The Irvin, Jewell, and Vinson Company, dealing in paint and glass, simply shifted operations from the rubble of its old location to another venue a short distance away. Several businesses made a point of taking photographs like this one, featuring a customer signing an order. (Courtesy of the NCR Archive at Dayton History.)

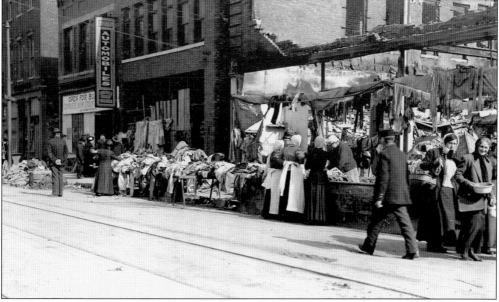

OPEN-AIR SHOPPING. Some businesses, robbed of both storefront and roof such as this clothing store on East Third Street, laid out their flood-damaged goods in an impromptu open-air market. Notice the smiling face of the woman to the lower right. (Courtesy of the Miami Conservancy District.)

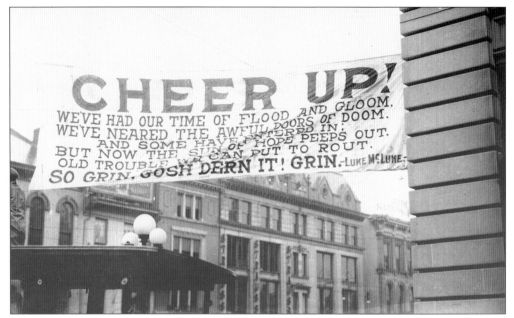

Cheer Up! Gosh Dern It! Encouragement was the message of six lines of rhyming doggerel painted onto a sheet hung on an unidentified Dayton street corner. Luke McLuke was the nom de plume of contemporary *Cincinnati Enquirer* journalist and humorist James Syme Hasting. McLuke's/Hasting's limericks and Twain-like aphorisms were syndicated nationwide, widely read, and even used in advertising. (Courtesy of the NCR Archive at Dayton History.)

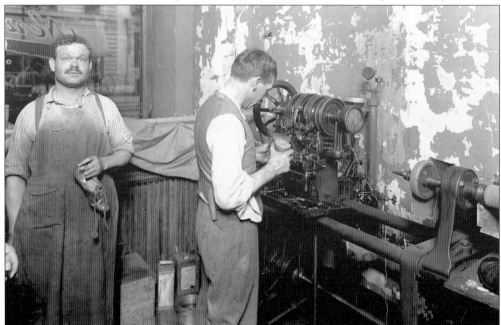

And People Cheered Up. Those with faith in the future fared well in post-flood recovery because flood victims now needed to replace or repair nearly everything. A shoe repair shop on Ludlow Street in October 1919, nearly seven months after the flood, was back to business as usual, despite evidence on its walls of the recent calamity. (Courtesy of the Dayton Metro Library.)

Six

RESOLVE

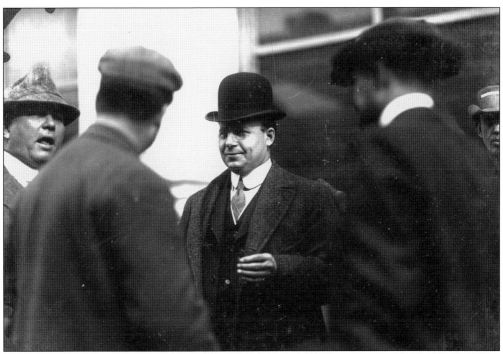

STATE CONCERN. As soon as roads were passable around Ohio, first-term Ohio governor James M. Cox arrived in Dayton on Wednesday, April 2 for a personal inspection of Dayton. Cox (center) had a personal connection to Dayton as he was publisher of the *Dayton Daily News* and a former journalist known for his bulldog-aggressive reporting. On this trip, he traveled with the state flood commission headed by Brig. Gen. John C. Speaks to inspect flood damage around the entire state (it is not known if any of the men shown here is Speaks). (Courtesy of the Dayton Metro Library.)

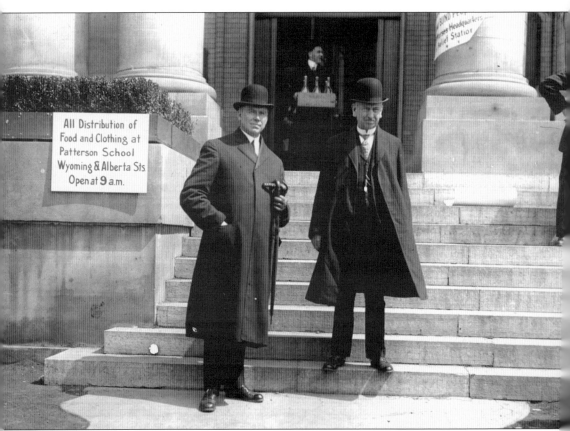

NATIONAL INTEREST. Within 24 hours of hearing about the flood, Pres. Woodrow Wilson dispatched Secretary of War Lindley Murray Garrison on a special train from Washington to Columbus, armed with full power to order Federal troops into Ohio as he deemed necessary without taking time to seek presidential approval. Traveling with Garrison were key officers from the army's Signal Corps, with orders to erect emergency wireless telegraphy (radio) field stations. Arriving on Saturday, March 29, Garrison made NCR his headquarters; on NCR's front steps, Garrison (left) is standing with U.S. Senator Theodore E. Burton of Ohio. On Monday, April 8, Burton presented a resolution to the U.S. Congress asking for a $2 million grant for the relief of the flood sufferers in Dayton—although in a statement to the Citizens' Relief Committee, Burton expressed doubt that Congress would respond for fear of setting a dangerous precedent of providing Federal aid for the relief of local disasters. Burton's pessimism was justified: Congress did not vote for any relief. (Courtesy of the Dayton Metro Library.)

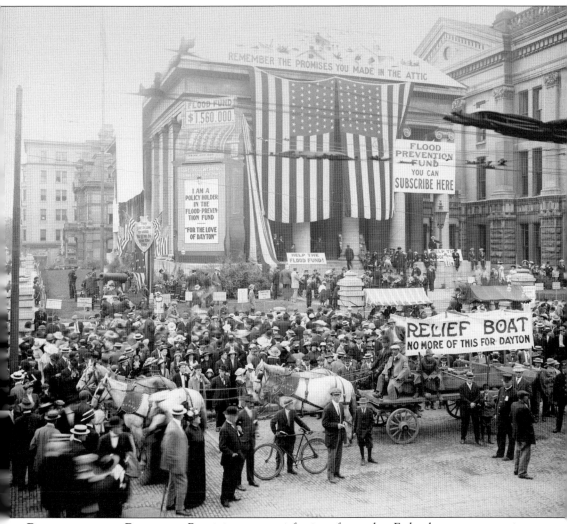

REMEMBER THE PROMISES. Receiving no satisfaction from the Federal government, in mid-May 1913, Patterson and NCR stirred Dayton to raise the requested $2 million from its own resources—as devastated as they were—for a fix-it-forever solution to flooding in the Miami Valley. It was a pledge-only campaign, in part to raise a larger total by allowing people to put down an initial five percent and make installment payments over the next three-and-a-half years against future income. Pledges were enormous: $10,000 each from the Dayton Savings and Trust Company and the Rike Kumler Company, $25,000 from Delco, and $50,000 from Dayton Power and Light Company. But the cornerstone of the campaign was NCR's own less-trumpeted pledge of $250,000 (equivalent to $5 million today). On the courthouse steps, the centerpiece of the last day of pledging, Sunday, May 25, was a 30-foot high working model of a cash register. But something was wrong. As late as 5:00 p.m. Sunday—around the time this photograph was taken—the campaign was still nearly half a million dollars (1913 dollars) short. (Courtesy of the NCR Archive at Dayton History.)

BEHIND CLOSED DOORS. That Sunday, Patterson called a meeting of all Dayton's leading citizens and industrialists at an NCR auditorium. He recounted Dayton's distinguished past and the institutions that must be protected in the future. Then he informed the audience that the shortfall must be subscribed then and there largely by those who had already subscribed to complete this great project of patriotism and sacrifice. He announced that the generous subscriptions he and his son and daughter had already made would be doubled if the audience responded in kind. Men jumped to their feet to double and triple their pledges. (Courtesy of the NCR Archives at Dayton History.)

TRIUMPHAL PARADE. About 9:30 p.m. Sunday, May 25, word was finally sent to the old courthouse that the final tally pledged by the rally at NCR was $2,125,000. A victory procession marched down Main Street to band music, applause, honking automobile horns, and fireworks. Among them was Patterson, who, as good as his word, doubled NCR's pledges to $500,000—the equivalent of at least $10 million in today's currency. (Courtesy of the Dayton Metro Library.)

BEGINNING THE JOB. By June 1913, the Citizens' Relief Commission of Dayton had hired the best hydraulic engineer in the country, brilliant 35-year-old Arthur E. Morgan (second row, third from right). In 1912, he made national headlines by testifying before the U.S. Congress, exposing widely publicized fraudulent attempts to dupe the public into buying land in the Florida Everglades on the basis of a false report that the wetland was suitable for drainage. (Courtesy of the Miami Conservancy District.)

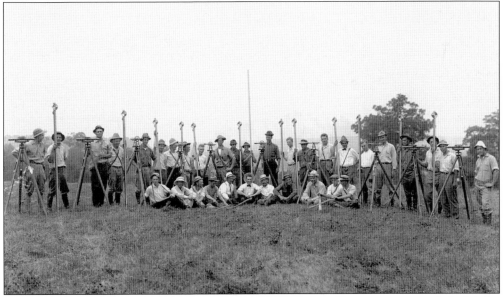

"MORGAN'S COWBOYS." Days later, Morgan fielded more than 50 engineers around the Miami Valley watershed to calculate the actual volume of water in the 1913 flood. In the absence of reliable maps, Morgan's men, some dressed as cowboys, surveyed the land themselves to ascertain its exact topography. With buckets of paint, they carefully marked high-water lines and interviewed residents to record the time of various flood stages. (Courtesy of the Miami Conservancy District.)

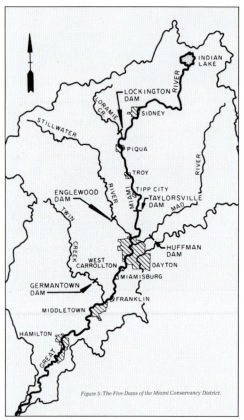

Figure 5: The Five Dams of the Miami Conservancy District.

DRY RETARDING BASINS. Morgan also deployed experts to Europe to examine stream-flow records going back centuries and even millennia—all to determine how to protect Dayton forever against a maximum possible flood. From all this data, Morgan determined that levees alone were not enough. When he presented his plans to the Citizen's Relief Commission in 1914, it outlined the single largest-scale engineering project ever undertaken in the United States up to then. The best protection for Dayton (and other Miami Valley cities and towns) would be provided by a system of massive earthen dams crossing five strategically narrow river valleys in the Great Miami watershed, four of them above Dayton. Morgan drafted a flood-control bill for the Ohio state legislature, which was quickly passed and signed into law by Gov. James M. Cox. Fifteen months later, after some prolonged political wrangling, the Miami Conservancy District was founded in 1915 to execute this pioneering engineering project. The district began moving earth in 1918 (somewhat delayed by World War I), financing the project by selling two issues of 30-year bonds totaling $34 million—then the largest special-assessment bond issue for flood control in U.S. history. (Courtesy of the Miami Conservancy District.)

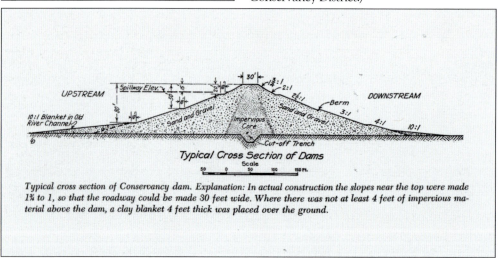

Typical cross section of Conservancy dam. Explanation: In actual construction the slopes near the top were made 1¾ to 1, so that the roadway could be made 30 feet wide. Where there was not at least 4 feet of impervious material above the dam, a clay blanket 4 feet thick was placed over the ground.

MORGAN'S PYRAMIDS. This diagram of the flood-control dams of the Miami Conservancy District shows their squat, triangular cross section, massive enough to hold back a volume of floodwaters 40 percent greater than that of 1913. At the base of each dam would be conduits, or pipes, forming a principal spillway left permanently open, enough to allow each river to pass unimpeded, even during normal spring freshets. But the conduits or spillway would be proportioned to hold back or retard any flow greater than what the riverbeds below could safely handle. (Courtesy of the Miami Conservancy District.)

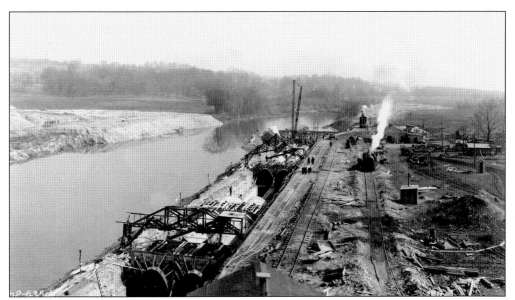

DIVERTING THE STILL WATER. To build each dam across its river, water was diverted from the work site through conduits. In March 1919, the outlets of the river-diversion conduits at the site of the prospective Englewood Dam were under construction, while the Stillwater River flowed as usual in its bed at left. The same was done at the sites for the other dams across the Great Miami and Mad Rivers as well as across Twin and Loramie Creeks. (Courtesy of the Miami Conservancy District.)

THE STILLWATER DIVERTED. Five months later, the Englewood Dam is shown from the same angle, showing the completed conduits and the normal bed of the Stillwater River to be nearly dry at the construction site. Downstream of the conduits in the distance, the river resumes its normal course. Now the riverbed is ready for constructing the dam. Englewood Dam, the largest and thickest of the five dams, is so huge that the enclosed conduits became a permanent part of the dam's structure. For the three smallest dams (Taylorsville, Huffman, and Lockington), the open conduits were built next to the river or creek, which was then diverted through the concrete structure before construction of the earthen embankment. (Courtesy of the Miami Conservancy District.)

MOVING EARTH. To build up the sides and height of each mammoth earthen dam, railway cars brought gravel and stone fill and dumped it into the site. Simultaneously, giant pumps directed fierce streams of water to move the fill into location. This excellent view of the hydraulic fill operations, taken in April 1919, was for Englewood Dam across the Stillwater River. (Courtesy of the Miami Conservancy District.)

SPILLWAY EXCAVATION. Before the main bulk of each dam was roughly built up, the spillway had to be excavated. In this photograph of the excavation for the spillway of the Taylorsville Dam in July 1919, the scale of operations is evident from the human figures at bottom. The dams ranged in height from 65 to 110 feet, and their crests ranged in length from 1,200 to 6,400 feet (Courtesy of the Miami Conservancy District.)

TAYLORSVILLE SPILLWAY DUG. A general view looking south (downstream) along the Miami River shows that the excavation for the Taylorsville Dam (foreground) was nearly completed by early February 1920. In the background, concrete is beginning to be poured. Because photographs of the progress of construction of any one of the four dams above Dayton are generally representative of all the others, the Taylorsville Dam is highlighted. (Courtesy of the Miami Conservancy District.)

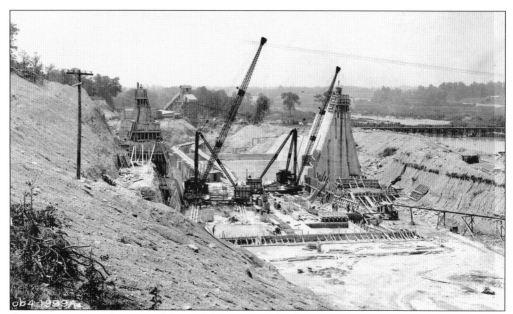

CONCRETING THE CONDUIT WALLS. The concrete for the western wall (right) of the Taylorsville Dam's spillway conduit, through which the Miami River will run, was already poured by July 1920. The eastern wall (left) was still surrounded by its wooden form. (Courtesy of the Miami Conservancy District.)

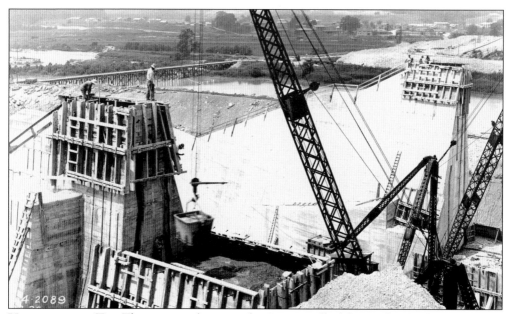

VIEW FROM THE TOP. The men standing atop the eastern wall of the conduit for the Taylorsville Dam give scale to the mammoth enterprise and the dizzying drop on all sides. (Courtesy of the Miami Conservancy District.)

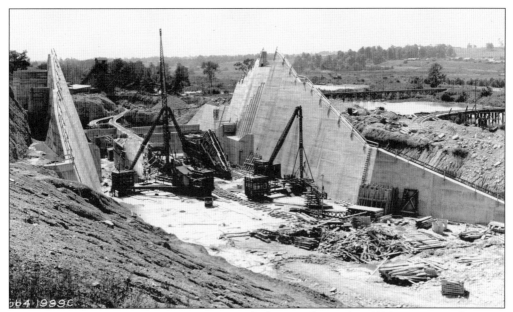

CONCRETING TAYLORSVILLE DAM. Two months later, in September 1920, progress is dramatic. Rising high above the derricks and other equipment are both concrete walls of the spillway conduit. Attention now is focused on the two tapering structures at the base of the spillway: the nose walls that will support the structure of the dam and the road atop it. (Courtesy of the Miami Conservancy District.)

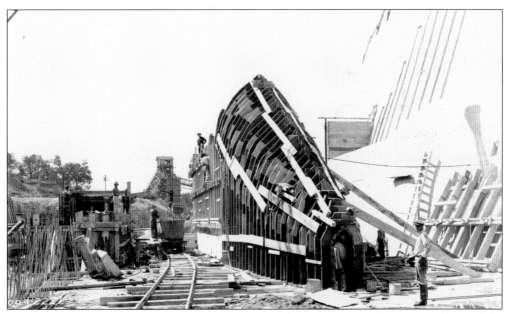

READY FOR POURING. The wooden form for one of the three nose walls in the spillway of the Taylorsville Dam is shown up close. Its size may be judged by the fact that a man is standing in the opening at its tapered end. The tapered ends will point upstream in the Miami River. (Courtesy of the Miami Conservancy District.)

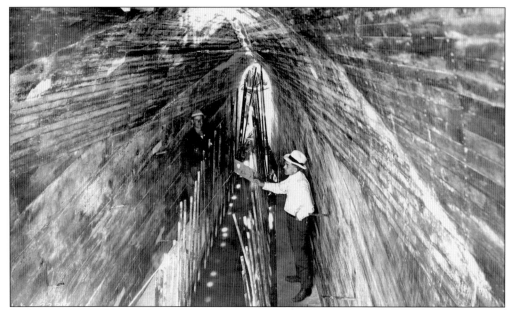

INSPECTING THE FORM. An engineer (man in white shirt with clipboard at right) inspects the interior of the wooden form for the Taylorsville Dam nose wall to make sure it is ready for concrete to be poured, while a workman (in dark clothes at left, scarcely visible except for the horizontal light band on his cap) looks on. (Courtesy of the Miami Conservancy District.)

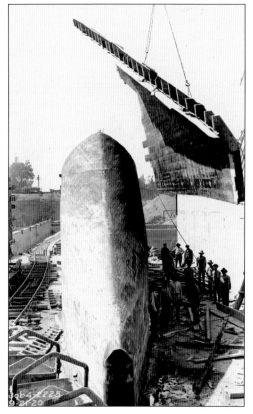

POUR SUCCESSFUL. Five days later, the wooden forms are removed from the successfully poured concrete nose wall at Taylorsville Dam. Note that despite the massive structure suspended overhead, 1920 was before the era of widespread use of hard hats on construction sites. (Courtesy of the Miami Conservancy District.)

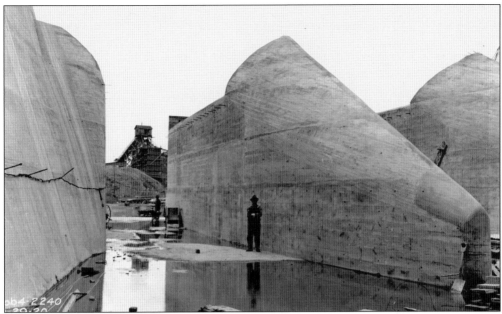

How Big Was It? The figure of the man at the base of the nose wall in the east opening of the conduit for the Taylorsville Dam gives an idea of the massiveness of the concrete structures. (The photograph appears to have been taken just after a rain.) By the end of the project, the Miami Conservancy District had poured 250,000 cubic yards of concrete for the dams, for their outlets, spillways, and roads across their crests. (Courtesy of the Miami Conservancy District.)

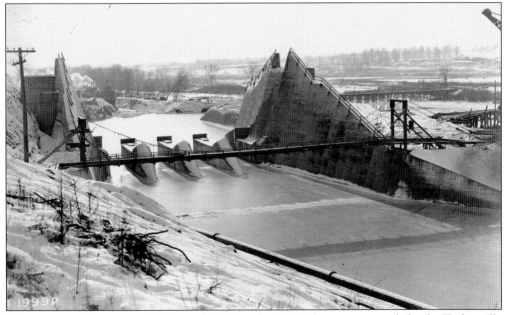

Concreting Suspended. By the end of December 1920, the concrete work for the Taylorsville Dam was temporarily completed for the winter, enough so the Miami River could be released from the temporary culverts to run in its regular course. Note snow on the ground. The small suspension bridge in the foreground carried the hydraulic fill pipe for continuing to build up the earthen dam on either side of the conduit. (Courtesy of the Miami Conservancy District.)

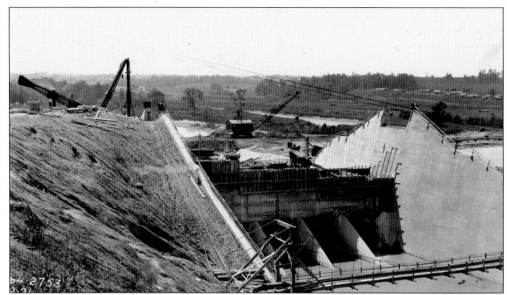

OVER THE TOP. By September 1921, concrete was being poured for the weir of the Taylorsville Dam. The weir, a curved concrete wall resting atop the tapered nose walls, is responsible for holding back or retarding floodwaters that rise above the nose walls so that no greater volume of water goes through the dam than can be handled by downstream levees and other flood-control measures. (Courtesy of the Miami Conservancy District.)

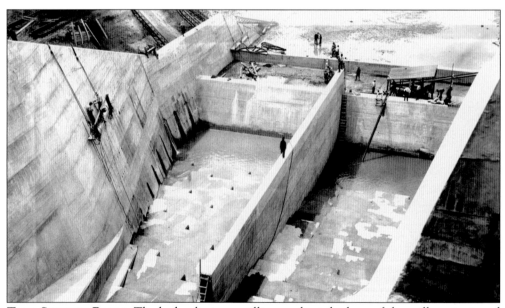

TWIN STILLING POOLS. The hydraulic jump stilling pools at the base of the spillway is viewed from the top of the Lockington Dam across the Loramie Creek near Piqua. The view is downstream (water would flow toward the upper right). Stair-step structures on the spillway's floor as well as the wall at the end are part of the innovative hydraulic jump used to dissipate floodwater's kinetic energy. Construction equipment is being removed in June 1919 just before allowing river water to enter. (Courtesy of the Miami Conservancy District.)

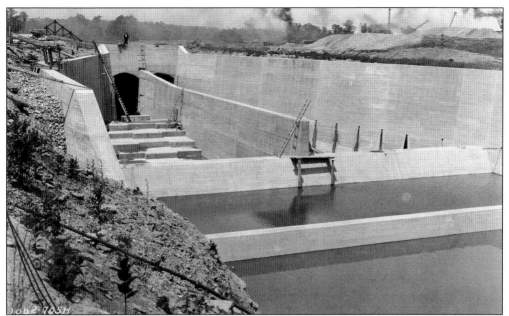

HYDRAULIC JUMP. The completed permanently open outlet conduit at Englewood Dam is shown, also in June 1919, right before letting the Stillwater River enter. This view, looking upstream from over the end wall at the base of the spillway toward the dam, better shows the hydraulic jump's stair-step structures on the spillway's floor that disperse the energy of the water (water would flow toward the viewer and off to the lower right). (Courtesy of the Miami Conservancy District.)

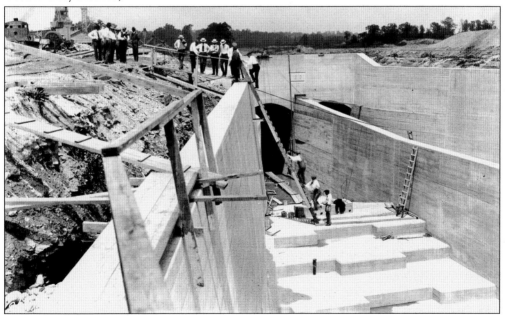

INSPECTING HYDRAULIC JUMP. Engineers climb a ladder up from the hydraulic jump of the Englewood Dam after inspecting the concrete and the construction in preparation to releasing the full force of the Stillwater River through its normal course. (Courtesy of the Miami Conservancy District.)

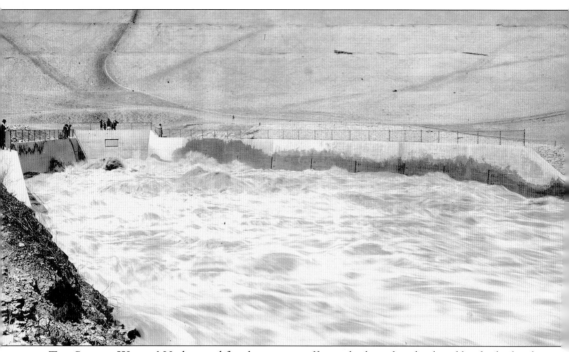

THE SYSTEM WORKS! High-speed floodwaters are effectively slowed and calmed by the hydraulic jump stilling basins, as shown in this photograph taken in the early 1920s, looking back upstream at the Englewood Dam from its south (downstream) side. Invisible behind the dam are the floodwaters it is holding back. The outlet ends of the conduits, usually visible under the far wall with the rectangle, are submerged. High-pressure floodwaters gush forth at speeds of 40 to 50 feet per second (35 to 40 miles per hour). In the middle of the photograph, near where the man is standing at the far left, the high-velocity water hits the submerged concrete end wall and is turned back on itself to slow itself. In the foreground to the bottom right, the water exits the stilling basin at less than 10 feet per second (about seven miles per hour), which can be safely carried by the natural river channel without erosion. Curving lines on the face of the earthen dam are dirt trails (which no longer exist). (Courtesy of the Miami Conservancy District.)

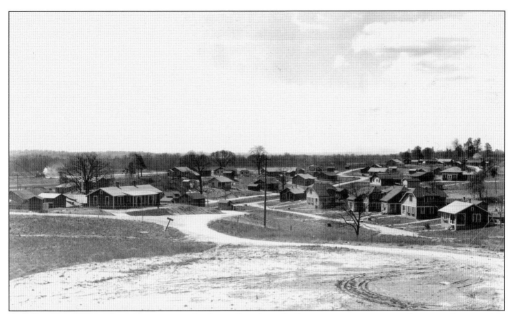

A WAY OF LIFE. The dams were fairly isolated and their construction took several years, so the construction workers as well as the Miami Conservancy District engineers overseeing them needed to live nearby. Arthur E. Morgan held strongly utopian views for communities of workers, so he saw that they had housing that was unusually pleasant for the era. This one shows the camp for the people working on the Taylorsville Dam. (Courtesy of the Miami Conservancy District.)

FAMILIES, TOO. The families of the men working on the five dams also lived on the premises, and schools were set up for their children. Shown here in December 1920 are the teachers and students at the school for the Taylorsville Dam camp. (Courtesy of the Miami Conservancy District.)

FOOD SUPPLY. Hungry construction workers and their families were fed in part by produce from a large vegetable garden planted near each dam, in this case for Taylorsville. To accommodate the areas that would be periodically flooded behind the five earthen dams, the Miami Conservancy District purchased some 30,000 acres in the Miami Valley—land made quite fertile by the occasional deposition of river silt from flooding. (Courtesy of the Miami Conservancy District.)

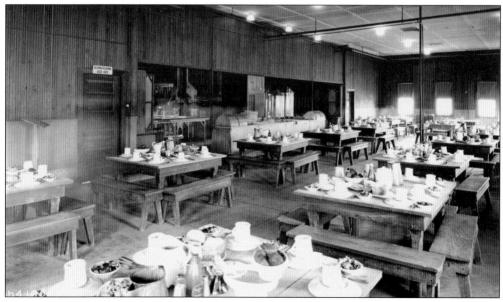

TAYLORSVILLE MESS HALL. Interiors of quarters were as pleasant inside as outside, as shown by the mess hall for the Taylorsville Dam, with the table set and food ready for a meal. This photograph was taken in May 1920. (Courtesy of the Miami Conservancy District.)

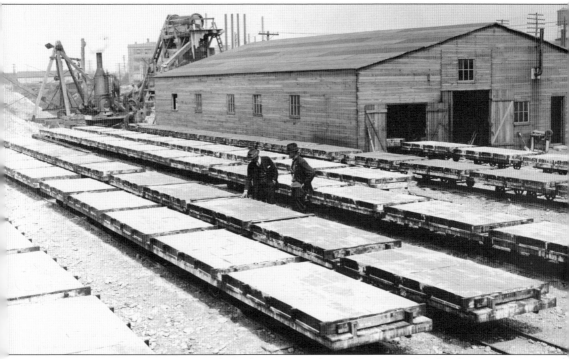

CONCRETE BLOCKS CURING. Meanwhile, downstream closer to Dayton, other flood-prevention measures would complement the earthen dams upstream in the Miami Valley. The riverbanks were to be reinforced by revetments or retaining walls to protect riverbeds at the foot of banks. For the revetments, some 400,000 concrete blocks were cast by Price Brothers, which relocated to Dayton from Michigan for the job. (Courtesy of the Miami Conservancy District.)

FLEXIBLE APPROACH. Flexible revetments were one of the innovations of the Miami Conservancy District. Relatively small blocks, measuring 24 by 12 by 5 inches, were used rather than solid slabs because they would not readily crack and break up under the force of floodwaters. This view, looking upstream along the Great Miami River, was taken near McKinley Park. (Courtesy of the Miami Conservancy District.)

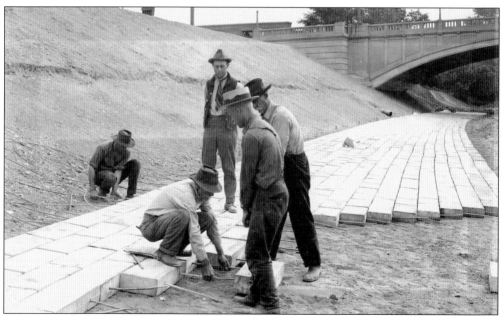

STRUNG TOGETHER. The concrete blocks were strung on galvanized iron cables that tied them into a flexible mat at the base of a levee. This view was just downstream from Webster Street. (Courtesy of the Miami Conservancy District.)

PULLING THROUGH. For the flexible revetments, the cables were pulled through the concrete blocks by an ingenious device. The view is looking upstream toward McKinley Park. (Courtesy of the Miami Conservancy District.)

SOLID REVETMENTS. Although flexible revetments were used right at the river's edge, solid revetments of larger concrete blocks were used higher up on the levee itself. This view, taken opposite Van Cleve Park looking upstream along the Miami River, shows the Webster Street Bridge in the background. (Courtesy of the Miami Conservancy District.)

WARPING BUT HOLDING. The flexible revetments at the base of the levee are shown in action looking downstream the Great Miami River just below Island Park Dam. Although the blocks warp, they hold together to protect the riverbank and levee from being eroded. (Courtesy of the Miami Conservancy District.)

Taylorsville Dam Completed. In March 1922, the completed Taylorsville Dam was photographed from the downstream side. The spillway is clearly visible with its three nose walls (tapers on the nose walls point away from the viewer). Above the nose walls is the curved concrete weir, capable of holding back floodwaters up to 40 percent greater than those of 1913. In the highly unlikely event any flood should be even greater, the openings between the weir and the highway bridge form an emergency spillway. Also well displayed is the bridge for the two-lane road running the length of the dam's crest. The dam's size can be gauged by the tiny human figures on the staircase at left. (Courtesy of the Miami Conservancy District.)

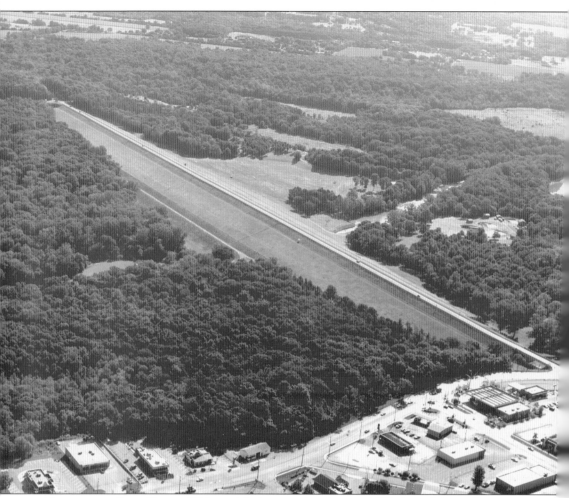

ENGLEWOOD DAM TODAY. This aerial photograph taken in 1993 shows Miami Conservancy District's Englewood Dam essentially as it appears today. Englewood, the largest of the five dams, stretches 6,400 feet across the Stillwater River, with water flowing from left to right. The dry detention basin at left today is filled with trees and in non-flood times offers the Miami Valley and Dayton a public recreation area. The road crossing the top of the dam is U.S. Route 40. (Courtesy of the Miami Conservancy District.)

BIBLIOGRAPHY

The American National Red Cross, *The Ohio River Flood of 1913: Official Report of Relief Operations.* The American National Red Cross, November 1930.
Bell Telephone News: Flood Edition. Chicago, 2 (10): [72 pages], May 1913
Becker, Carl M., and Patrick B. Nolan. *Keeping the Promise: A Pictorial History of the Miami Conservancy District.* Dayton, OH: Landfall Press, 1988.
Bock, C. A. *History of the Miami Flood Control Project.* State of Ohio: The Miami Conservancy District, Dayton, Ohio, 1918.
Bombakidis, Elli, ed. *1913: Preserving the Memories of Dayton's Great Flood.* Proceedings of a symposium sponsored by the Dayton Metro Library, Ohio Humanities Council, Miami Conservancy District, Ohio Preservation Council, and Beavercreek Women's League; Dayton Metro Library, 2004.
Brevoort, Kenneth and Howard P. Marvel. "Successful Monopolization Through Predation: The National Cash Register Company." Ohio State University. http://www.econ.ohio-state.edu/pdf/marvel/ncr.pdf.
Clatworthy, Linda M. "Ohio Libraries in the Flood," *The Library Journal,* 38 (11): 602–607, November 1913.
Dalton, Curt. *Through Flood, Through Fire: Personal Stories from Survivors of the Dayton Flood of 1913.* Dayton, OH: Mazer Corporation/Curt Dalton, 2001.
Dayton: Being a story of the great flood as seen from the Delco Factory. Dayton, OH: Delco, April 1913.
Horton, A. H. and H. J. Jackson. *The Ohio Valley Flood of March–April, 1913, Including Comparisons with Some Earlier Floods.* Washington, D.C.: Department of the Interior, United States Geological Survey, Water-Supply Paper 334, Government Printing Office, 1913.
McCampbell, E. F. "Special Report on the Flood of March, 1913," *Monthly Bulletin Ohio State Board of Health.* May 1913: 299–445.
Morgan, Arthur E. *The Miami Conservancy District.* New York: McGraw-Hill, 1951.
Talbert, Roy, Jr. *FDR's Utopian: Arthur Morgan of the TVA.* Jackson, MS: University Press of Mississippi, 1987.
U.S. Department of Agriculture, U.S. Weather Bureau. *Monthly Weather Review,* January 1913 and March 1913.
Wood, George H. *Report of General George H. Wood on the Dayton Flood in the Annual Report of the Adjutant General to the Governor of the State of Ohio for the Year Ending November 15, 1913.* Springfield, OH, 1914.

Discover Thousands of Local History Books
Featuring Millions of Vintage Images

Arcadia Publishing, the leading local history publisher in the United States, is committed to making history accessible and meaningful through publishing books that celebrate and preserve the heritage of America's people and places.

Find more books like this at
www.arcadiapublishing.com

Search for your hometown history, your old stomping grounds, and even your favorite sports team.

Consistent with our mission to preserve history on a local level, this book was printed in South Carolina on American-made paper and manufactured entirely in the United States. Products carrying the accredited Forest Stewardship Council (FSC) label are printed on 100 percent FSC-certified paper.